CUBA, CARS
AND CIGARS

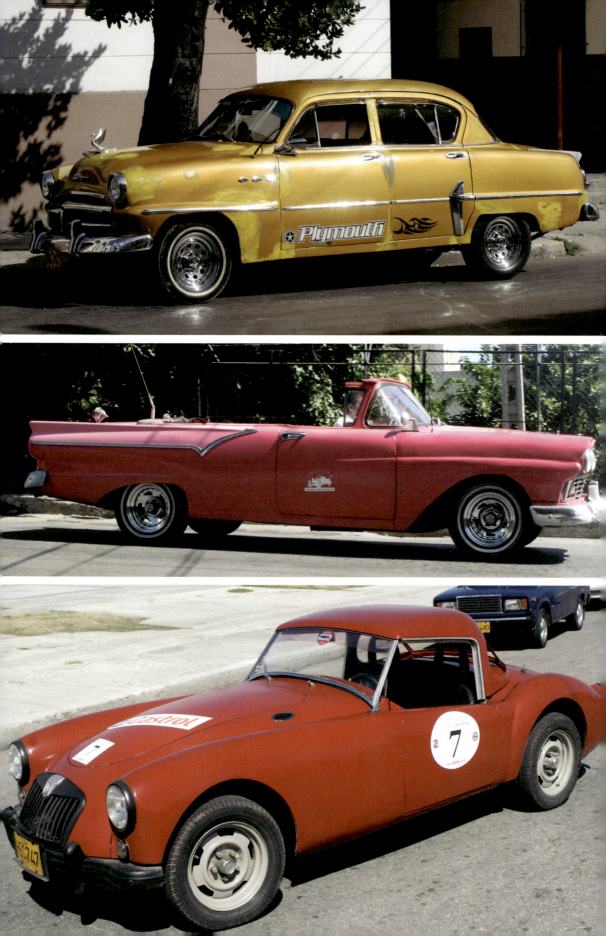

CUBA, CARS AND CIGARS

CLASSIC 1950s AMERICAN AUTOMOBILES

MARTIN W. BOWMAN

FONTHILL

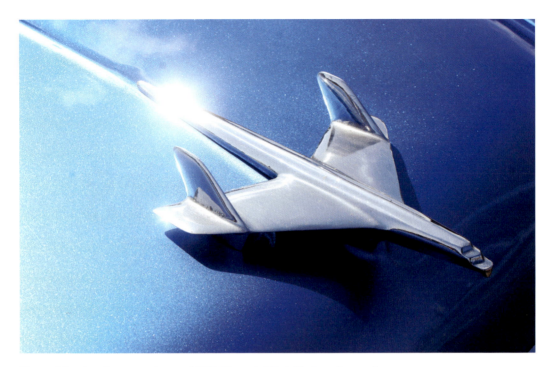

The striking hood ornament on a 1955 Chevrolet Bel Air four-door sedan.

Previous page: 1954 Plymouth Belvedere (top); 1957 Ford Fairlane 500 Sunliner (middle); MGA (bottom).

FONTHILL MEDIA
www.fonthillmedia.com

First published by Fonthill Media 2012

Copyright © Martin Bowman 2012

All rights reserved

Martin Bowman has asserted his rights under the Copyright, Designs and Patents Act 1988 to be identified as the Author of this work

No part of this book may be reprinted or reproduced or utilized in any form or by any electronic, mechanical or other means, now known or hereafter invented, including photocopying and recording, or in any information storage or retrieval system, without the permission in writing from the Publishers

ISBN 978-1-78155-188-2 (print)
ISBN 978-1-78155-213-1 (e-book)

A CIP catalogue record for this book is available from the British Library

Typeset in 10.5pt on 13pt Sabon LT Std
Typesetting by Fonthill Media
Printed in the UK

CONTENTS

Introduction	7
Timeline	11
American Classics	17
European Classics	109
Havana Sights and City Lights	125

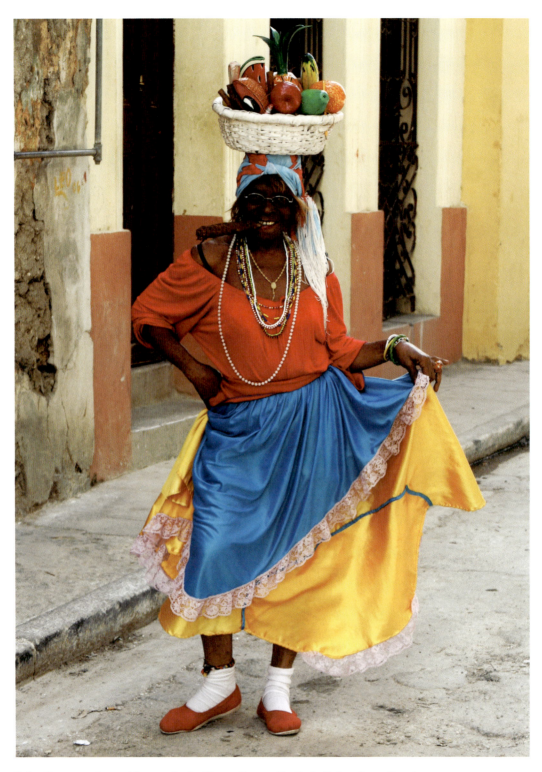
A local woman dressed for carnival with another particularly Cuban love, the cigar.

INTRODUCTION

Very little is new in Cuba. About 150,000 classic cars existed at the time of the Revolution. In 1960, when Fidel Castro declared Cuba a People's Republic and opened its doors to the Soviet Union, the US reacted by imposing economic sanctions and breaking diplomatic ties. In April 1961, when the US-backed Bay of Pigs invasion ended in humiliation for the Americans, the embargo became absolute. Relations deteriorated further still in 1962 with the Cuban Missile Crisis, a secret agreement between Cuba and the Soviet Union to base nuclear weapons on the island.

It is estimated that today there are 60,000 classic cars in Cuba, including Chevys, Buicks, Caddys, Fords, Packards, Pontiacs, Plymouths, Chryslers, Dodge, Willys, Oldsmobiles and DeSotos to name but a few. All have been passed down from generation to generation in good running order with several careful owners. About half are from the 1950s, and the other half are divided between the 1940s and '30s; all were shipped to Havana from factories in Detroit.

Britain might have been first with the sports car and Italy the coupe, but Detroit became the car fashion capital of the world. Its jet-age art deco designs or Motown monstrosities sculpted by auto architects such as Bill Mitchell, Harley Earl, Virgil M. Exner, Raymond Loewy and Dutch Darrin are symbolic of a golden age in automobile design. These masters created stylised natural forms and symmetrical utilitarian 'space age designs for earth travel', and adapted them for mass production.

From the streamlined 1934 Chrysler Airflow, which took its inspiration from pioneering aircraft design, to the prototype dorsal-finned 1948 Cadillac, the definitive post-war American family sedan began to take shape.

Dorsal fins – originally little more than a jumped-up tail light that progressively mushroomed to shoulder height – soon found their way onto other GM cars such as the Oldsmobile (1949), Buick (1952), Chrysler (1955), Hudson, Studebaker, Nash (1956) and Ford (1957). Designers crafted curvaceous cars with 'winged rockets and bosomy 38-inch D-cups', which alluded to Jane Russell (and Sabrina in England), but were the result of propeller bosses or 'spinners' on planes. In 1950, Studebaker stepped out of

the crowd with a new 'bullet nose' front, and two years later, Ford introduced a 'triple-spinner' grille that, in time, would become a Ford hallmark. The aeronautical influence, it seemed, was inescapable, and further validated by the 1951 Le Sabre, named after the F-86 jet fighter.

Virgil Exner, however, who in 1949 had left Studebaker to head corporate styling at Chrysler, favoured 'classic' design elements: upright grilles, circular wheel openings and rakish silhouettes. Ten years on, his 1959 Plymouth Fury was dart-like. In 1948, Oldsmobile's George Snyder refined his so-called 'fishmouth' grille and, in so doing, defined the frontend shape of Oldsmobiles for a decade.

The design gurus then went 'chrome crazy' adding acres of chrome trim to bodies and beltlines; they crafted art-deco bonnet ornaments and hood scoops so that cars were distinguishable from a block away. Gravel guards, Frenched headlights, jet intake bumper guards, swept-wing hood ornaments, gull-wing grille emblems and cats-eye and twin-tower tail lights all became fashion accessories. Oldsmobile coined rocket-shaped tail light lenses and a saucer-sized medallions; Buick's trademarks were a cigar-in-a-hoop ornament, vertical buck-tooth chrome dentures in a horizontal grinning 'Fashion-Aire Dynastar grille', ventiports (portholes) and the sweep spear; Pontiac had an Indian head and round tail lamps; Cadillac, a chrome 'V' on the hood and deck lid; Nash Rambler's had an egg crate grille; and De Soto's bonnet ornament glowed in the dark. Only Chevrolet needed no specific signature because Chevys were already so popular that everyone recognised them.

Exner once said, 'A well-styled car will make a man feel better at the end of his journey than when he started.' He liked to see classic lines bolted onto modern cars. Raymond Loewy considered design '...far too important to be left in the careless hands of company men in suits'. He might well have been referring to Henry Ford who famously once said that buyers of his cars could have any colour as long as it was black. Jet-age designers wanted two-tone colours like Parklane Green, Yosemite Yellow and Country Club Tan. Elvis and Mamie Eisenhower were pioneers of pink, while Jayne Mansfield owned a pearl-coloured '57 Continental with mink trim.

Mere mortals were seduced by Hounds-Tooth upholstery, full-leather trim and fashionable wall-to-wall carpets which atoned for extravagant arrays of gadgetry and gimmicks. Chrysler's 1957 New Yorkers' equipment included power windows, a six-way power seat, Hi-Way Hi-Fi phonograph Electro-Touch radio, rear seat speaker, instant air heater, handbrake warning system, Air-Temp air-conditioning and tinted glass. The four-finned '59 Pontiac Bonneville's rowdy interior included a Wonderbar radio, electric antenna, tinted glass, padded dash, tissue dispenser and as much chrome as the exterior. An under-dash air-conditioning unit was optional.

Although there are more classic cars in the US overall, Cuba, with its concentration of cars, is like a snapshot of 1950s USA. Visitors feel they have stepped into a time warp. Sedans, coupes, convertibles, rag-tops and station wagons share the bustling streets of Havana and the sparsely populated roads outside the capital. These 'Last Chance Saloons', also known as 'Yank tanks', 'máquinas', 'cacharros' and 'bartavias', are complemented by vintage Hillmans, Fiats, SAABs, Mercs, Singers, Austins, horse-drawn carts, elderly motorcycles and increasing numbers of boxy Eastern Bloc Ladas, vulgar Volga sedans and Japanese imports.

Since the collapse of the USSR and the subsequent derailment of Cuba's sugar trade, the island has opened itself to Western tourists, although western capitalism is still firmly resisted. Former plantations are being converted into tourist resorts along the coast, but there are enduring reminders of the tough regime in the propaganda billboards and the repressive dual currency system.

Thanks to a solid economic alliance with the Soviet Union in the 1970s and '80s, one in four cars in Cuba is a Lada – an ugly cousin of the Fiat 124 – and a good proportion of the others have Lada engines. During the 1990s, impoverished taxi drivers created the 'Stretch Limo Lada' and ingenious mechanics have even grafted roofs and body panels onto old sedans to create 'people carriers'. Looking underneath the hood of these veteran vehicles reveals an engine that bears little resemblance to its manufacturer's original. Component parts of anything from old tanks to Ladas are used to power anything from washing machines to 1951 Plymouths.

Cherished heirlooms and practical vehicles, classic cars have become an intricate part of Cuba's heritage. With love and devotion they have been preserved through the decades but, inevitably, with the scarcity of parts and lack of original factory literature to maintain them, the classic car is a dying breed in Cuba. So, make sure you enjoy this crazy, contradictory country before these 'Last Chance Saloons' disappear forever.

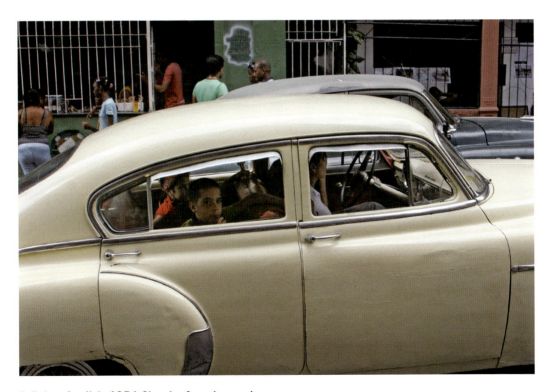

A Cuban family's 1954 Chrysler four-door sedan.

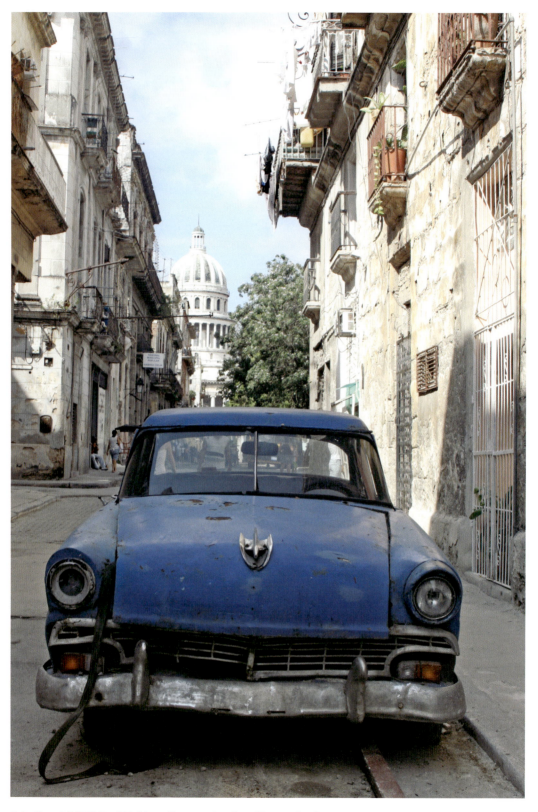
A battered 1956 Ford Fairlane Town sedan in a Havana backstreet.

TIMELINE

1948
Chevrolet top car manufacturer with 696,449 cars. Ford, who in 1930 sold 1,140,710 cars, are third with 247,722 cars.

1949
One millionth Cadillac rolls off the production line. Chrysler enters the 1950s as a lower-medium price make with seven series and twenty-four models. Ford is the largest car manufacturer with 1,118,308 cars. Chevrolet comes second with 1,010,013 cars.

1950
Chevrolet is America's No. 1 car maker with 1,498,590 cars sold. First proper Motorama show opens at New York Waldorf. Only 333 Volkswagen Beetles sold in entire US. First modern compact, the Nash Rambler – 'only' 176-inches long – is introduced. President Truman sanctions building of US's first H-bomb. Diners' Club plastic credit card appears followed by the American Express card. Mao Tse Tung and Stalin sign Mutual Defense Treaty. Joseph McCarthy launches crusade against Communism. First major US battle in Korea. First kidney transplant. In the US, 2,200 cinemas are built per year. First nuclear test in Nevada desert. The Third Man wins Oscar for black-and-white photography.

1951
Chevrolet is America's No.1 car manufacturer with 1,229,986 cars sold. Ford-O-Matic is Ford's first fully automatic transmission. Chrysler announce all-new 331cid hemi-head V8 for the New Yorker, plus power steering for first time. Hop Up magazine launched, for hot-rodders and customisers. Office of Price Stabilization allows some car manufacturers to raise prices. One in three US cars is automatic. Average US salary is $1,456 p.a. A Streetcar Named Desire voted best movie of 1951. US Atomic Energy Commission says it can produce electric power from nuclear reactors. Betty Crocker's Picture Cookbook, first out in 1950, sells its millionth copy.

1952

In March, General Fulgencio Batista overthrows the elected government of Carlos Prio in an almost bloodless coup in Cuba. National steel strike in US and the Korean War slow car production. Chevrolet largest car manufacturer (with 818,142 cars) for third year in a row. Ford regains the No. 2 spot in manufacturer volume with 671,733 cars.

Buick is third largest maker of convertibles and largest hardtop builder. Ford's first totally new body since 1949 features a one-piece curved windshield, 'Frenched' headlights, a 'triple-spinner' grille and backlight to give the car a wider appearance and a new rear-end theme that would become a Ford hallmark: round tail lights. Ninety-five per cent of all Fords are powered by a V8 engine. Office of Price Stabilization ends pegging of new car prices. Eisenhower elected President with largest-yet popular vote. Contraceptive pill introduced. Americans spend $255 million on chewing gum, $235 million on greeting cards and $23 million on mouthwash. Gene Kelly stars in Singin' in the Rain. TWA launch tourist class air travel. Nationally televised detonation of atomic bomb in Nevada desert.

1953

Chevrolet is America's No. 1 car maker with 1,346,475 cars. Ford second with 1,247,542 cars. GM lose $10 million. Dodge launches famed Hemi V8 and optional air-conditioning. More chrome as Korean War eases. On 26 July, Castro leads a group of 150 rebels in a surprise attack on a military garrison in Santiago de Cuba with the intention to unseat the dictatorship of General Fulgencio Batista. Chrysler introduce PowerFlite automatic. Marilyn Monroe is America's favourite pin-up and appears on the cover of Playboy. Nikita Khrushchev is the new Communist Party leader after Stalin's death. Levis are America's No. 1 jeans. A young Elvis Presley walks into Sun Studios, Memphis.
From Here to Eternity premieres. Soviets admit they have the H-bomb. Cinemascope launched. New 'stiletto' heels declared 'dangerous'.

1954

Ford overtake Chevrolet (1,143,561 units) as top manufacturer with 1,165,942 cars. Spinner hubcap becomes most popular accessory in America. Harley Earl previews first Firebird experimental car at Motorama. Packard merge with Studebaker. First nuclear submarine launched. Ray Kroc of San Bernadino, a high-school drop-out, comes up with a newfangled stand for selling French fries, soda and 15c hamburgers: today it is known as McDonald's.

Eisenhower proposes new Interstate highway system. IBM launch first computer. Boeing unveil prototype 707.

Second H-bomb exploded at Bikini Atoll. Elvis sings That's All Right. Racial segregation outlawed in US schools.

Premiere of Seven Brides for Seven Brothers.

1955

Fidel Castro released from prison in Cuba and leaves for exile in Mexico. Highest Ford output since 1923 (1,451,157 cars), but Chevrolet are back on top producing 1,704,667

cars. Cadillac's most successful year to date with 141,777 cars built. Detroit ships eight million new cars to showrooms, accounting for $65 billion or twenty per cent of the Gross National Product. Big three car manufacturers dominate ninety-seven per cent of market. General Motors becomes the first corporation to earn $1 billion in a single year and their touring Motorama exhibitions draw two million visitors at every stop. US production at post-war high. Imperial, Dodge, Plymouth and DeSoto become separate marques from Chrysler. Car manufacturers agree to ban advertisements promoting performance and horsepower. Ford Fairlane (named after Henry Ford's mansion at Dearborn, Michigan) launched. 60,000 foreign cars, including 25,000 VW Beetles, imported into the US. $17 million Disneyland opened by Walt Disney on 13 July watched by twenty-four live ABC cameras and hosted by Ronald Reagan. James Dean killed in a car accident on 30 September while driving his Porsche Spider. He is twenty-four years old. New phrase 'Rock 'n' Roll' coined by DJ Alan Freed. 3-D movies launched. Billboard introduces Top 100 record chart. Bill Haley's Rock Around the Clock is No. 1 for twenty-five weeks. Marlon Brando wins Best Actor for On The Waterfront. Soviets test H-bomb.

1956

Chevrolet is America's No. 1 car manufacturer with 1,567,117 cars. America owns three-quarters of all the cars in the world. Harley J. Earl heads GM's state-of-the-art $125 million Tech Centre in Michigan and leads a styling team of 1,200 people. Federal Highway Act passed. Martin Luther King Jr fights for black rights using peace. JFK goes for Vice-President nomination. To celebrate eleven hit records, Elvis buys his first pink Cadillac. First videotape shown. My Fair Lady opens. Sixty per cent in US own homes. In December, Castro captains a barely seaworthy vessel named Granma from Mexico to the southern shore of Cuba to re-launch the revolution.

1957

'57 Coupe de Ville comes with air-conditioning as standard. Ford, with all-new styling, outsell Chevrolet 1,676,449 to 1,505,910. New Ford Skyliner is world's first hardtop convertible. Chevrolet call their '57 line 'sweet, smooth and sassy'. Chevrolet offer fuel injection and first 1 hp/cii in engine. Thunderbird sales up by half. Edsel launched. Introduced at Ford dealers on 18 April 1957, the new '57 Ford Skyliner Retractable is Detroit's first collapsible hardtop. A Turnpike Cruiser wins the Indianapolis 500. Magazine Custom Cars is launched. USSR first in space with Sputnik. Disney's dream world welcomes ten millionth visitors, most of who have arrived by car. Eisenhower and Nixon sworn in for second term. Jack Kerouac's novel On the Road, which was to set the mood for a whole generation and demonstrated how road culture was now a subliminal part of America's national psyche, published. Breathalyser tested to measure alcohol. 'Cat', 'dig', 'cool', 'square' and 'hip' enter the language. Elvis stars in his first movie, Jailhouse Rock. Bogart dies of throat cancer. Jerry Lee Lewis sings Great Balls of Fire. Mercury Turnpike Cruiser boasts gadgets such as a retractable Breezaway rear window and a forty-nine position driver's seat and is hailed as 'space age design for earth travel'.

1958

Chevrolet regains lead in car manufacture with 1,142,460 built. Ford is No. 2 with 987,945. An industry-wide recession leads to worst sales since the Second World War. Dodge production falls by more than fifty per cent to 137,861 and retains only 3.1% of the market. Very last Packard rolls off the South Bend, Indiana, line on 13 July. According to Time magazine, 1958 car buyers are confused by the wild offerings of 'jet intakes, bubble windshields, downswept snouts, upswept fins and outswept tail lights'. Chicago motivational researcher Louis Cheskin claims that the reason cars were not selling was due to the launch of the Sputnik and the new '58 models that were being launched: 'The discovery that while we were fussing with useless decorations, the Russians were making satellites and intercontinental rockets ... (this) has had a profound psychological effect on almost every American.' Thunderbirds get four seats. Ford offer Level-All ride for one year only. Fiftieth birthday for Chevrolet. GM employs four women in their design department. Studebaker offer compact Lark. First US satellite launched. Pan American World Airways begin first transatlantic flights. NASA created. Elvis drafted. First stereo record on sale. Hope Diamond donated to Smithsonian Institution. West Side Story opens. Danny and the Juniors have a smash hit with At The Hop. Last Communist newspaper, The Daily Worker, folds.

1959

Chevrolet is America's No.1 car manufacturer with 1,462,140 cars; Ford No. 2 with 1,450,953. Fidel Castro becomes Cuban premier. Harley Earl, Vice-President of GM's styling division, retires. Bill Mitchell, who admires clean, sculptured lines and claims that to be a real car designer you have to have 'gasoline in your veins', takes over. John Keats, in his book The Insolent Chariots, likens the American car to an overweight concubine: 'With all the subtlety of a madam affecting a lorgnette, she put tail fins on her overblown bustle and spouted wavering antennae from each fin.' Chrysler offers an upper medium line with fifteen models and four series. Nixon and Khrushchev hold 'kitchen debate'. First Soviet rocket to reach the moon. UK's first motorway, the M1, opens. Bobby Darin wows with Mack The Knife. Alaska and Hawaii join the Union as the forty-ninth and fiftieth states respectively.

Buddy Holly, Ritchie Valens and JP 'The Big Bopper' Richardson die in a plane crash. GM touts its Firebird IH at the New York and Boston Motorama shows: billed as 'Imagination in Motion', it has an ultrasonic key that was aimed at the door, a cockpit pre-heater, a formed plastic interior and the steering wheel, transmission lever, brake and throttle were all worked from a single joystick control. Castro appears on This Is Your Life. Architect Frank Lloyd Wright and Errol Flynn die. Race riots in Little Rock. Cars feature in the television series 77 Sunset Strip. Bonanza and The Twilight Zone begin their television runs. Popular movies at the drive-ins are Some Like it Hot, North by Northwest and Ben Hur.

1960

All US businesses in Cuba appropriated without compensation. US breaks off diplomatic relations.

Chevrolet (1,653,168 cars) trounce Ford (1,439,370) in model, year and production.

Edsel dropped after three disastrous years. Compact Chevrolet Corvair, Ford Falcon, Mercury Comet and Plymouth Valiant appear. Car production doubles that of 1950. Steel strike means aluminium on grilles and hubcaps gains popularity. Ten million families own cars. JFK and Nixon hold live TV debate. Castro stirs a crowd of 250,000 into frenzy, charging that the US is fomenting counterplots against him. Cuba resumes formal relations with the Soviet Union. Soviets shoot down US U-2 spy plane over Russia. Ten blacks shot dead in worst-ever race riot in Mississippi. Ben Hur receives a record ten Oscars. Psycho opens. DeSoto close down after building 2,024,629 cars on 30 November.

1961
DeSoto nameplate disappears. Ford and Chevrolet introduce new cast-iron engines. Ford is America's No. 1 car manufacturer with 1,338,790 cars; Chevrolet No. 2 with 1,318,014 cars. Lincoln introduce dazzling new Continental. Dodge launches compact Lancer. Pontiac launches Tempest with transmission at rear to eliminate gearbox hump in interior. Oldsmobile introduce F-85. Industry introduces lifetime chassis lubrication and self-adjusting brakes. JFK sworn in as President. US break diplomatic ties with Cuba. Anti-Castro revolutionaries fail to invade Cuba in Bay of Pigs disaster. Castro announces that Cuba has become a communist state with a Marxist-Leninist programme of economic development. JFK sends 100 'advisors' to Vietnam. Berlin Wall erected. Yuri Gagarin first man in space.

1962
Chevrolet is America's No. 1 car manufacturer with 2,072 million cars; Ford is No. 2 with 1,476,031 cars. Cuba expelled from the Organization of American States (OAS). Fins and two-tone paint disappear from most ranges. Ford and Chrysler offer V8s with 400 hp. Buick offer new V6. JFK embargoes all Cuban imports. Marilyn Monroe dies. More US aid for South Vietnam. Telstar satellite launched. Cuban Missile Crisis brings world to brink of nuclear war. Soviet nuclear missiles removed from Cuba at US insistence.

1963
A new record achieved by Detroit with 7.3 million cars being made. Of these, sixty-one per cent have a V8 engine and every eighth car is an estate model. Chevrolet is America's No. 1 car manufacturer with 2,148 million cars; Ford is No. 2 with 1,525,404 cars. New sport cars debut: Buick Riviera, Corvette Stingray and the Studebaker Avanti. The Avanti was designed by Raymond Loewy (1893-1987), one of the prime architects of the American Dream who shaped everything from pencil sharpeners, streamlined trains, the Lucky Strike cigarette pack, the interior of Skylab and Coca-Cola dispensing-machines to the inside of JFK's official jet, Air Force One, Colds pot refrigerator, Greyhound Scenicruiser bus and the Hallicrafter radio. His other motoring credits include the Studebaker Commander, Starliner, Golden Hawk and Champion. GM introduce the Tilt-Away steering wheel. Chrysler offer a new 50,000 mile warranty. Detroit agrees to install seatbelts on 1964 models.

JFK assassinated in Dallas. Khrushchev warns the world that Russia has 1,000 megaton A-bomb. Five US helicopters shot down in Mekong Delta.

1964
Chevrolet is America's No. 1 car manufacturer with 2,308,700 cars; Ford is No. 2 with 1,594,053 cars. These are followed in turn by Pontiac, Plymouth, Buick, Dodge and Oldsmobile.

1965
Cuba's only political party is renamed the Cuban Communist Party (PCC). With Soviet help, Cuba begins to make considerable economic and social progress. Chevrolet is America's No. 1 car manufacturer with 2,372,900 cars; Ford is No. 2 with 2,170,795 cars.

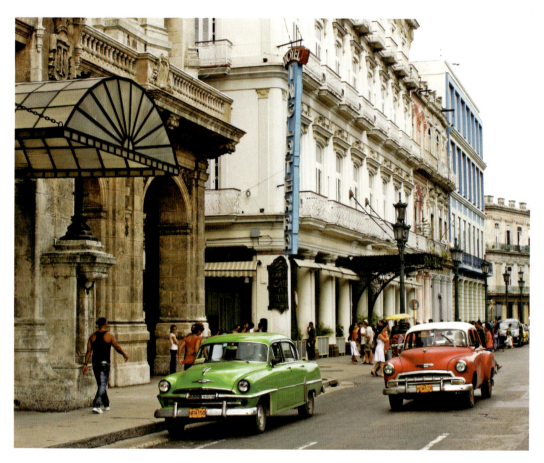

1954 Plymouth Belvedere 4-door sedan passing a 1952 Chevrolet Styleline outside a Havanan hotel.

AMERICAN CLASSICS

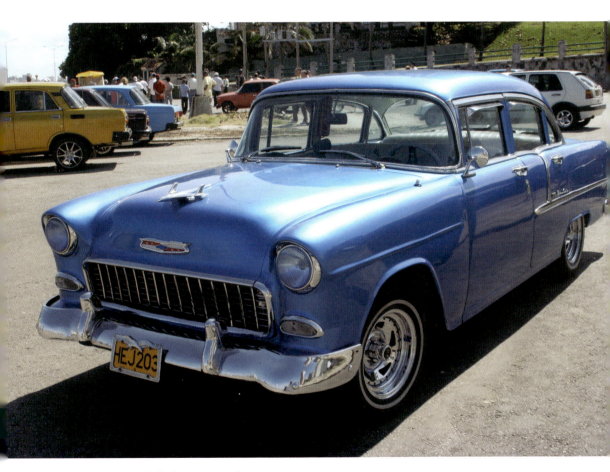

1955 Chevrolet Bel Air four-door sedan.

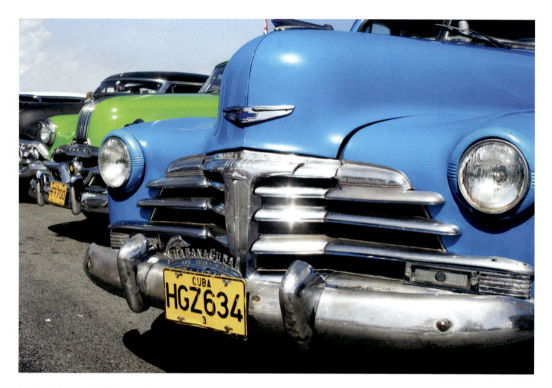

1946 Chevrolet Stylemaster.

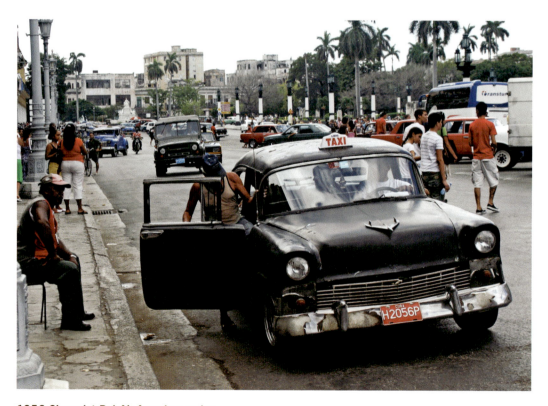

1956 Chevrolet Bel Air four-door sedan.

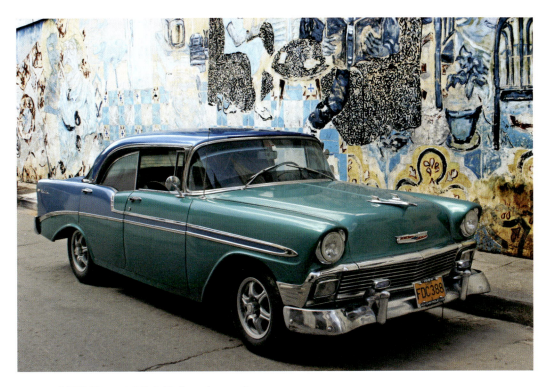

1956 Chevrolet Bel Air four-door sedan.

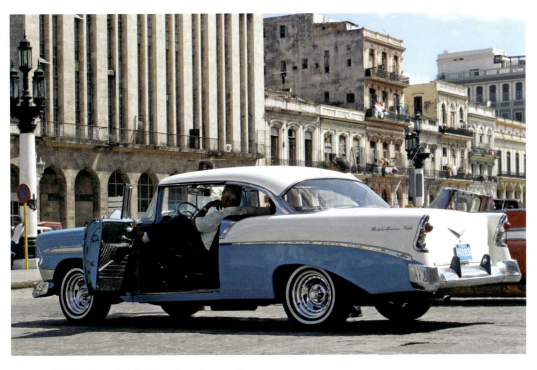

1956 Chevrolet Bel Air four-door sedan.

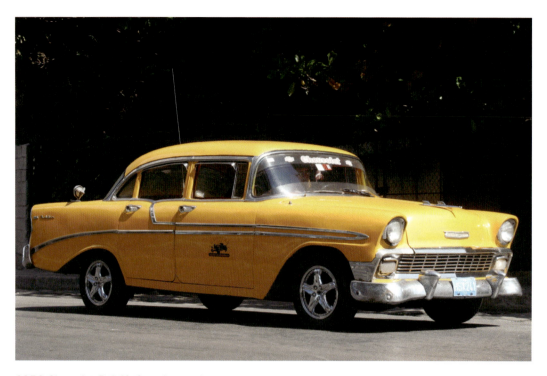
1956 Chevrolet Bel Air four-door sedan.

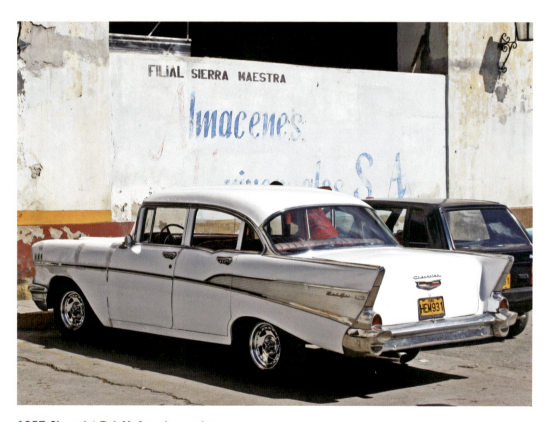
1957 Chevrolet Bel Air four-door sedan.

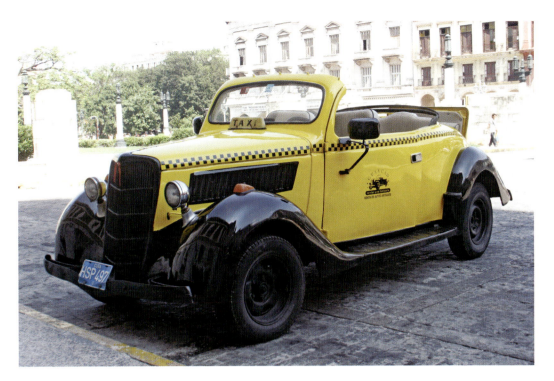

1937 Ford.

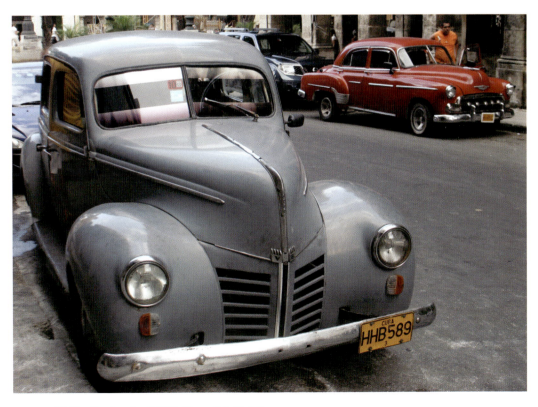

1940s Ford and a 1952 Chevrolet Styleline.

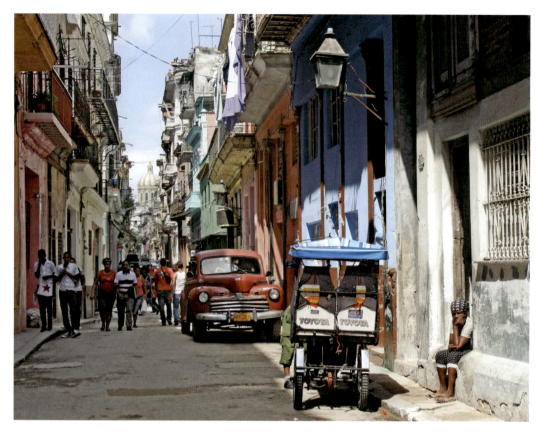

1946 Ford Super DeLuxe Fordor Sedan.

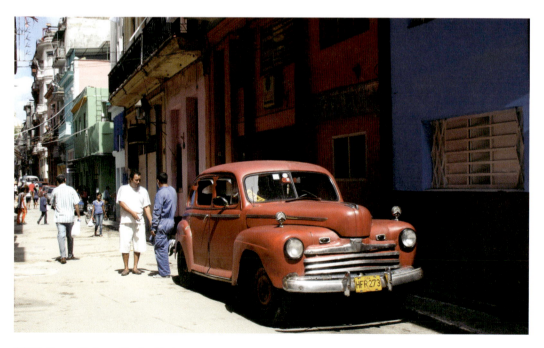

1946 Super DeLuxe Fordor Sedan.

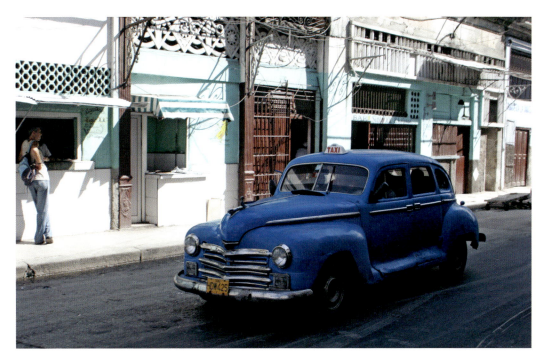

1946-48 Dodge Custom D-24-C.

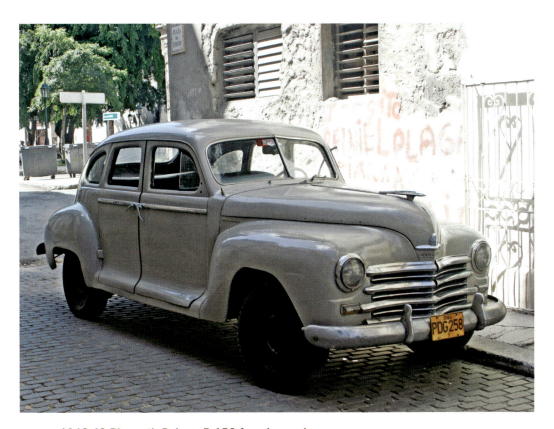

1946-48 Plymouth DeLuxe P-15C four-door sedan.

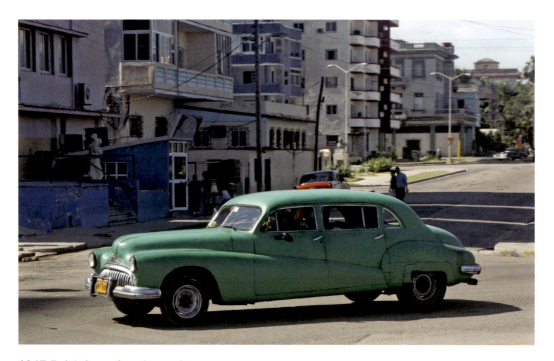

1947 Buick Super four-door sedan.

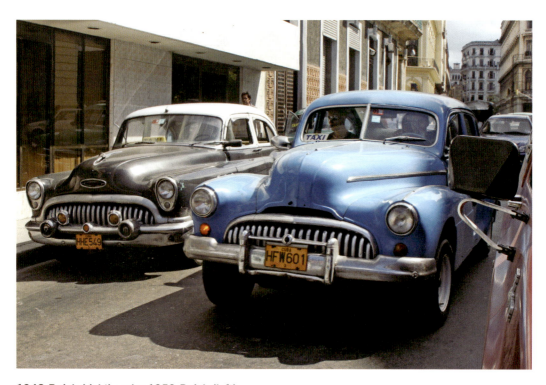

1948 Buick (right) and a 1953 Buick (left).

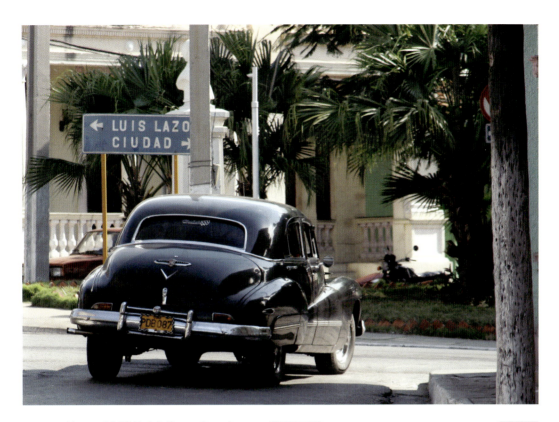

Above: **1948 Buick Super four-door sedan.**

Right: **1949 Chevrolet station wagon.**

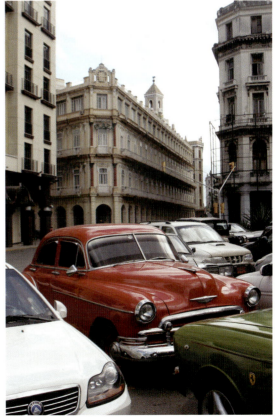

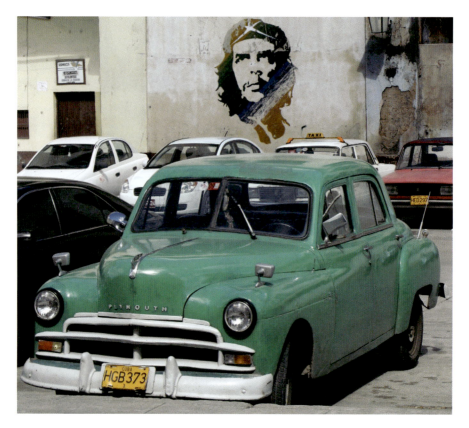

1949 Plymouth P-19 four-door sedan.

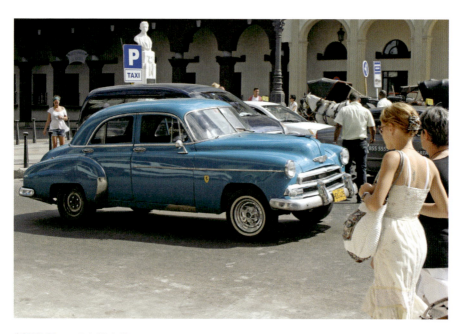

1950 Chevrolet Styleline.

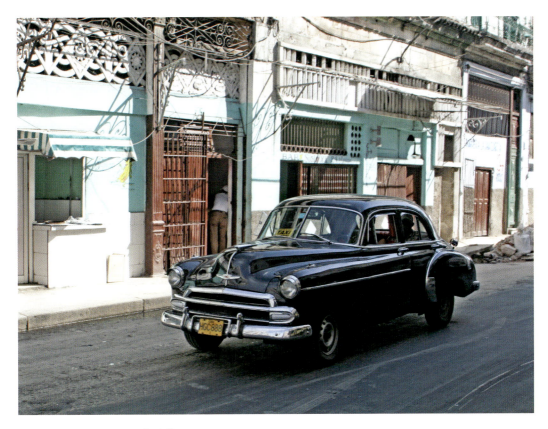

1950 Chevrolet Styleline.

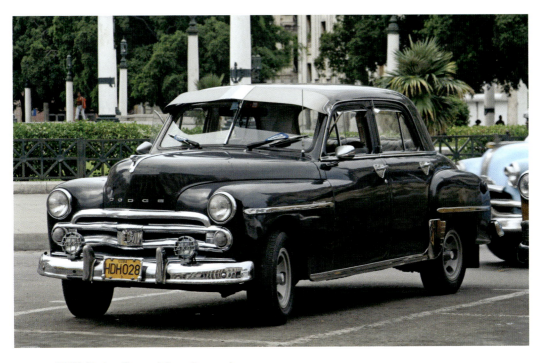

1950 Dodge Coronet four-door sedan.

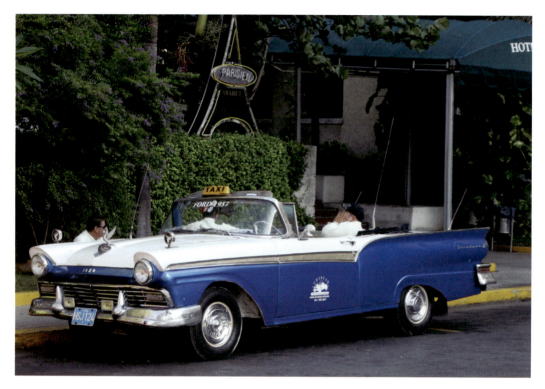
1957 Ford Fairlane 500 Sunliner convertible coupe.

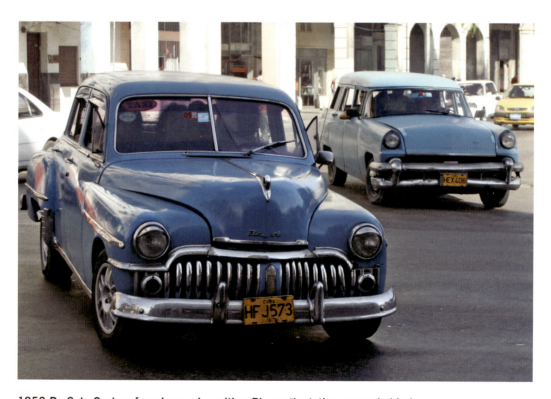
1950 De Soto Custom four-door sedan with a Plymouth station wagon behind.

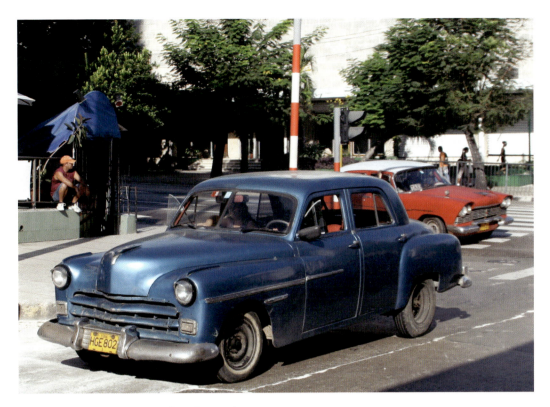
1950 Dodge Coronet four-door sedan.

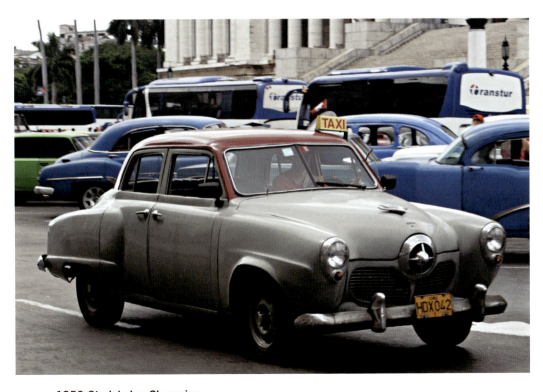
1950 Studebaker Champion.

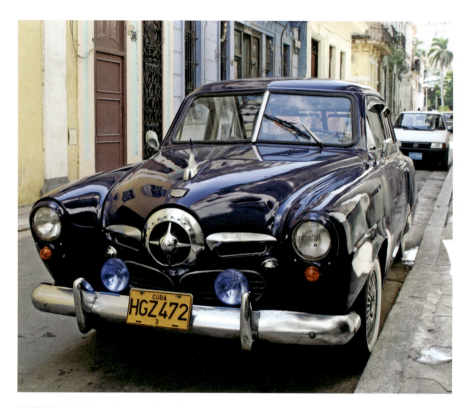

1950 Studebaker Commander Regal DeLuxe four-door sedan.

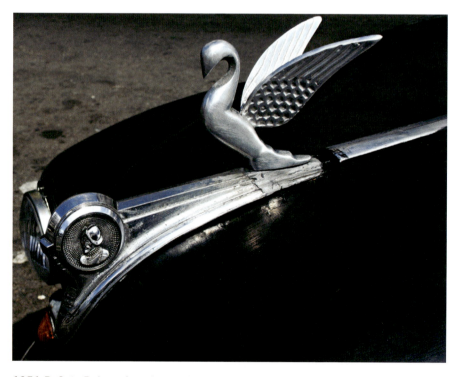

1951 DeSoto DeLuxe four-door sedan.

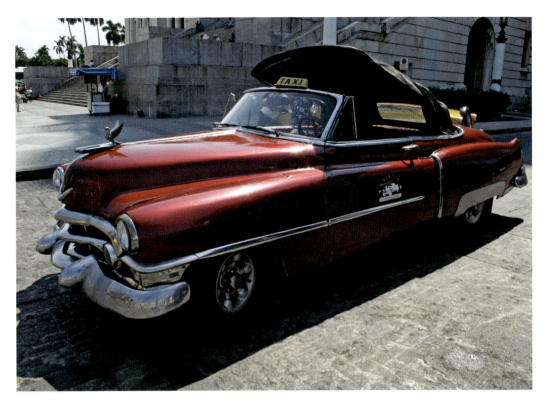
1951 Cadillac Series Sixty-Two convertible coupe.

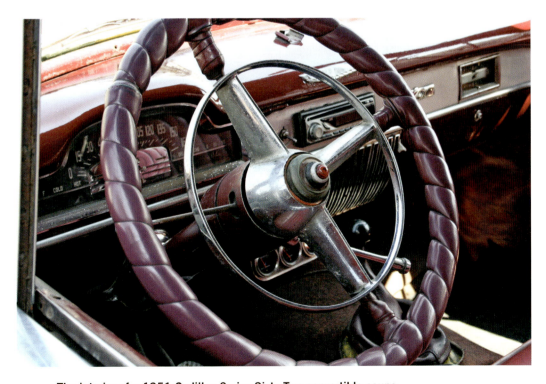
The interior of a 1951 Cadillac Series Sixty-Two convertible coupe.

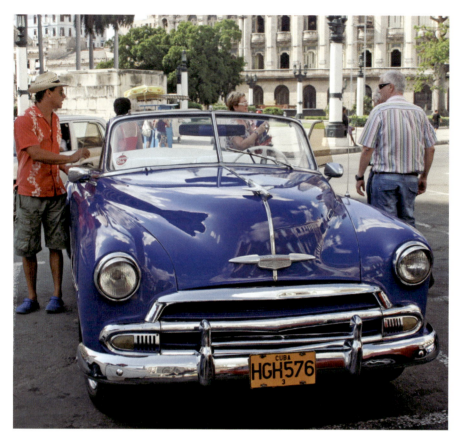

1951 Chevrolet Styleline DeLuxe convertible coupe.

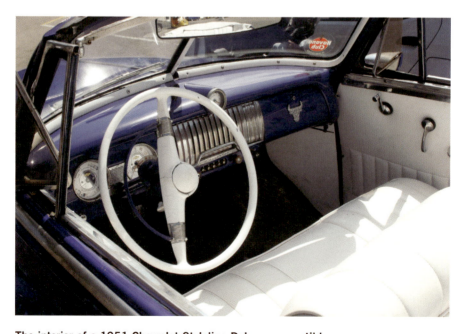

The interior of a 1951 Chevrolet Styleline DeLuxe convertible coupe.

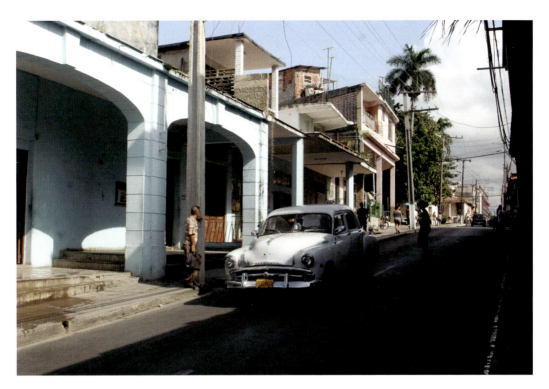
1951-52 Plymouth P-23 Cranbrook four-door sedan.

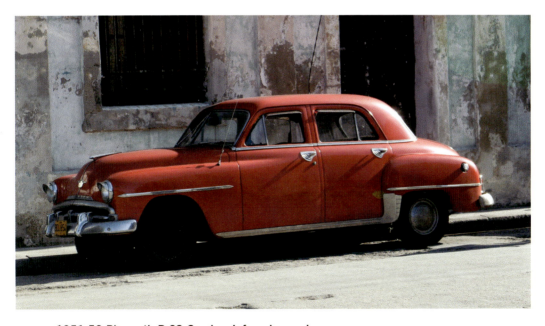
1951-52 Plymouth P-23 Cranbrook four-door sedan.

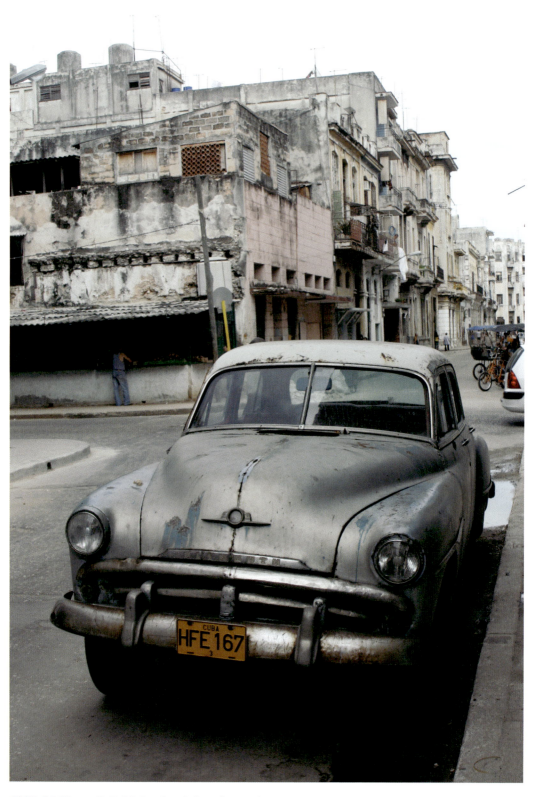

1951-52 Plymouth P-23 Cranbrook four-door sedan.

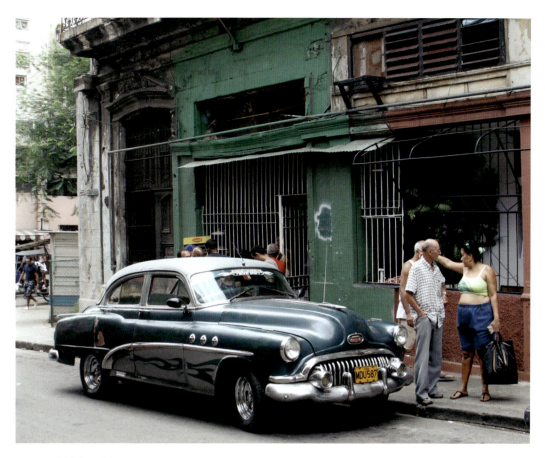

1952 Buick 41D DeLuxe four-door sedan.

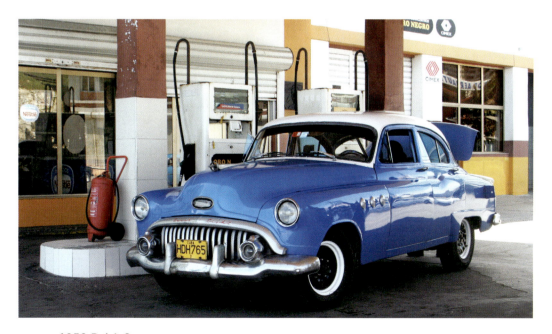

1952 Buick 8.

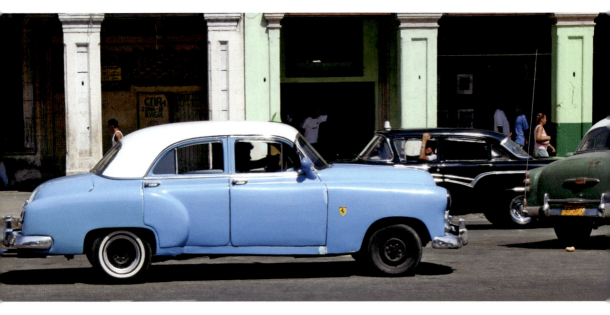
1952 Chevrolet four-door sedan.

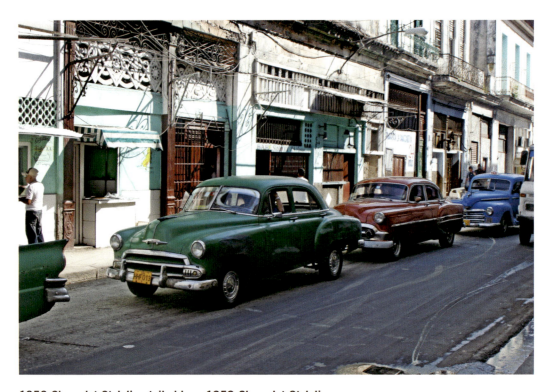
1952 Chevrolet Styleline tailed by a 1953 Chevrolet Styleline.

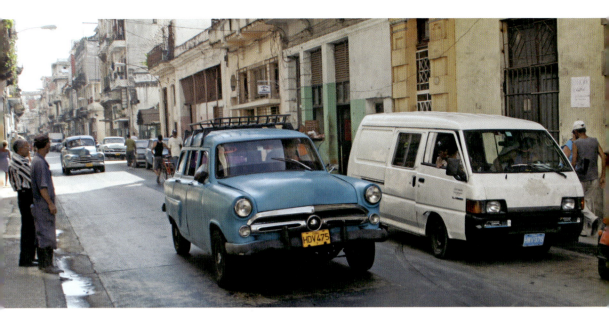

1952 Ford Country sedan.

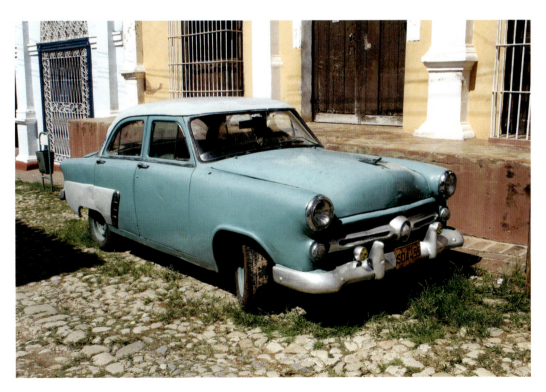

1952 Ford Mainline Fordor.

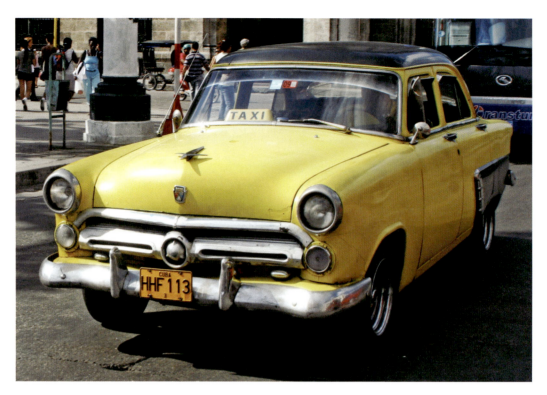

1952 Ford Mainline Fordor.

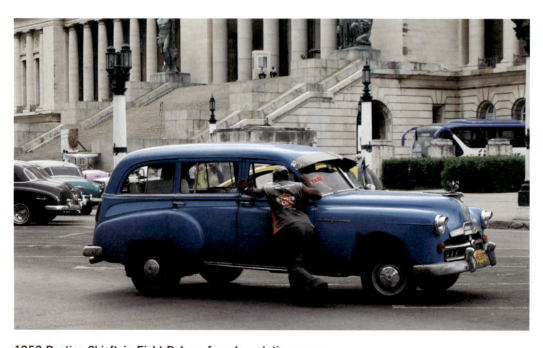

1952 Pontiac Chieftain Eight DeLuxe four-door station wagon.

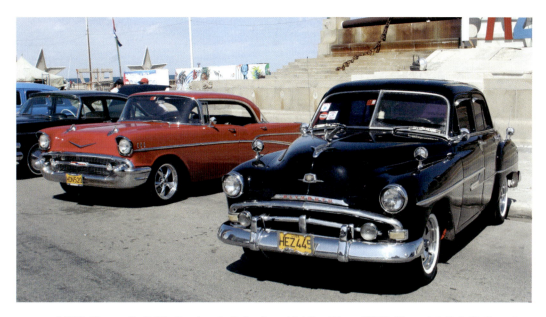

1952 Plymouth P-23 Cranbrook Belvedere (right) with a 1957 Chevrolet Bel Air four-door sedan (left).

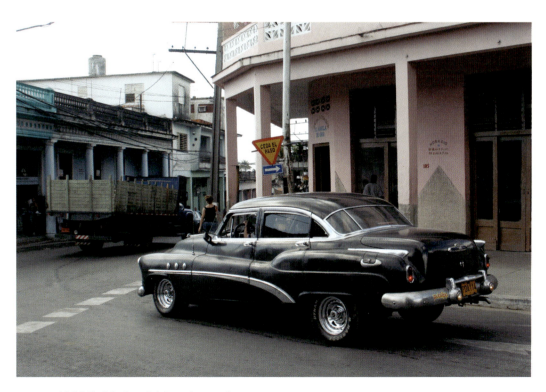

1952 Buick Special four-door sedan.

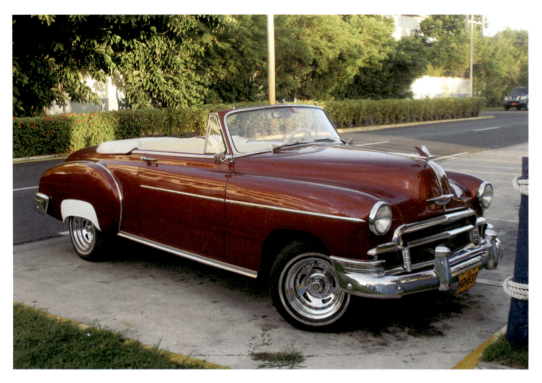
1952 Chevrolet Styleline DeLuxe convertible coupe.

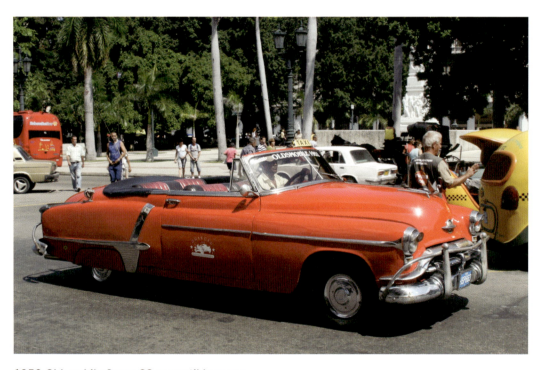
1952 Oldsmobile Super 88 convertible coupe.

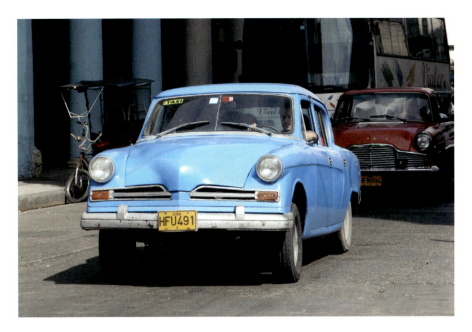

1953 Studebaker four-door sedan.

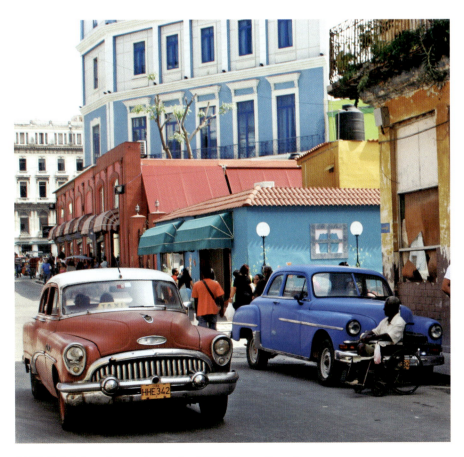

1953 Buick four-door sedan and a 1951 Plymouth sedan.

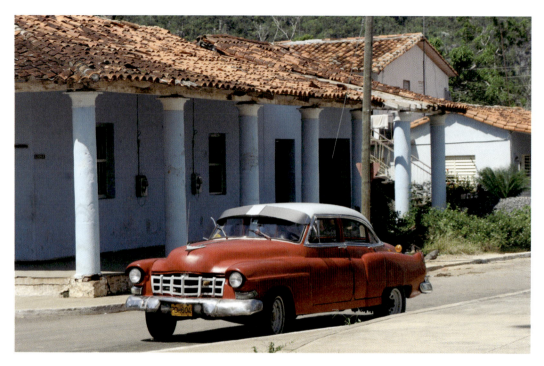

1953 Cadillac four-door sedan.

1953 Chevrolet Bel Air, 1951 DeSoto DeLuxe four-door sedan and a 1951 Chevrolet Convertible coupe.

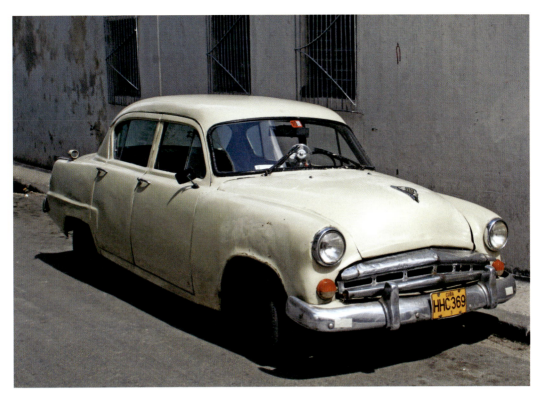
1953 Dodge Coronet Eight four-door sedan.

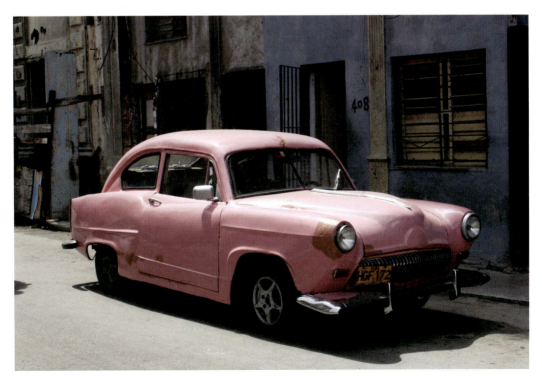
1953 Henry J Corsair two-door fastback sedan.

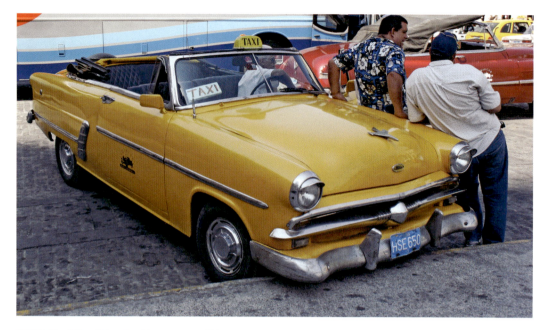
1953 Ford Crestline Sunliner convertible coupe.

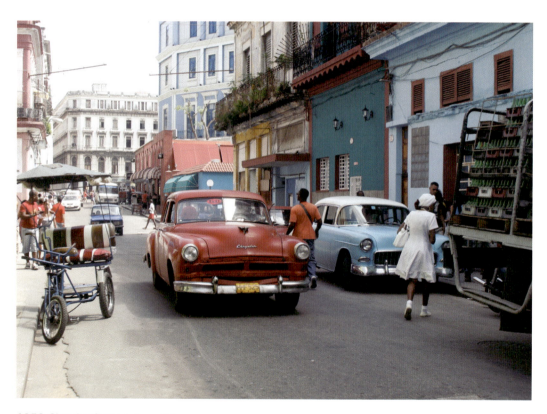
1953 Chrysler Custom Imperial.

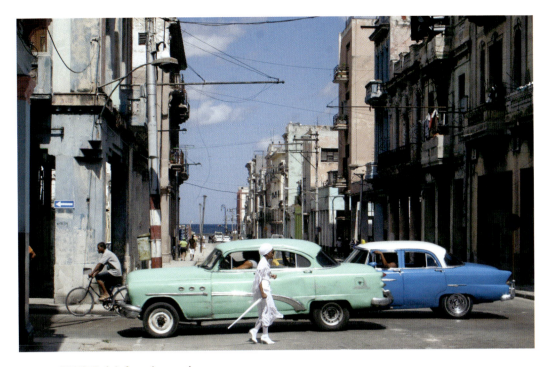
1953 Buick four-door sedan.

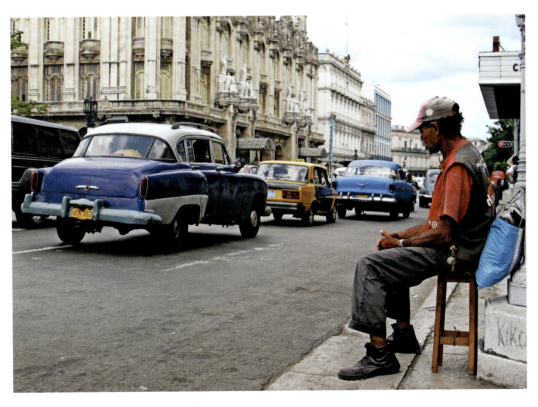
1954 Chrysler four-door sedan.

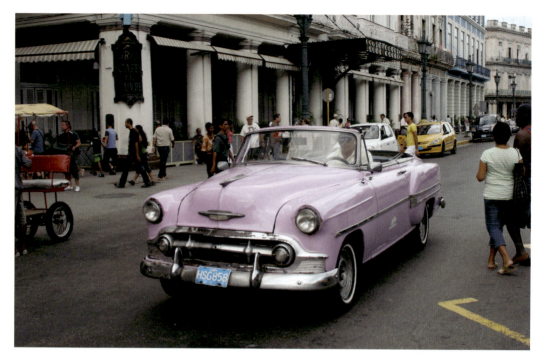

1954 Chevrolet Bel Air convertible coupe.

1954 Buick Century four-door sedan.

1954 Chevrolet Handyman Wagon.

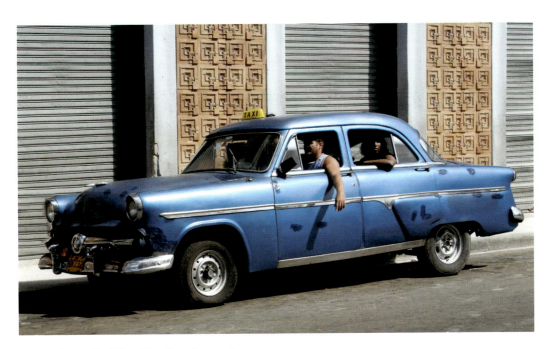
1954 Ford Crestline four-door sedan.

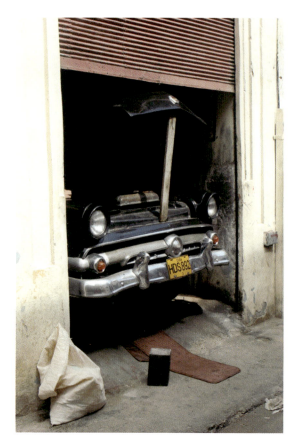

Left: **1954 Ford Crestline.**

Below: **1954 Mercury Monterey four-door sedan.**

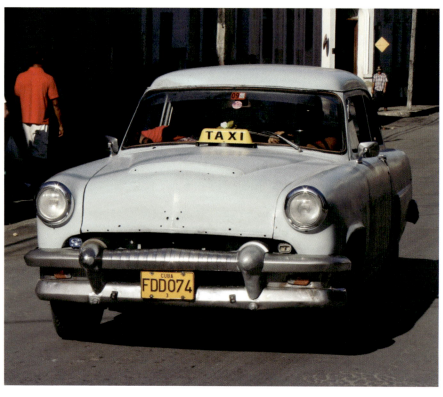

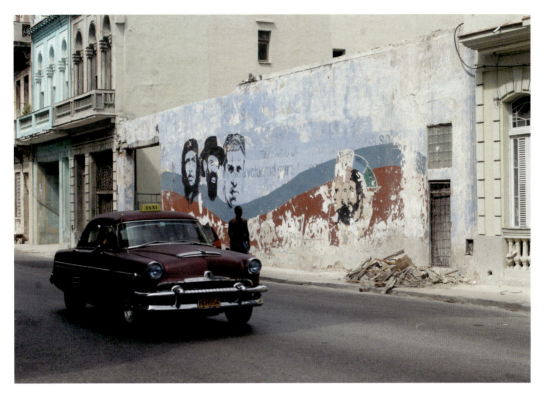

1954 Mercury Monterey four-door sedan.

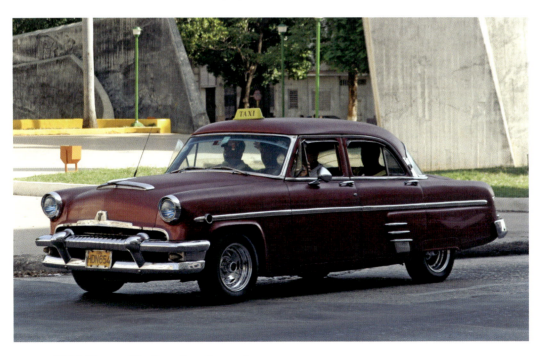

1954 Mercury Monterey four-door sedan.

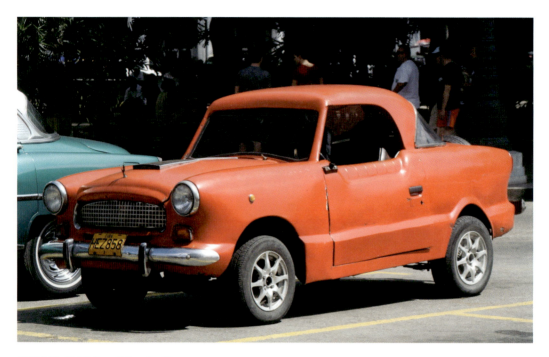
1954 Nash Metropolitan hardtop coupe.

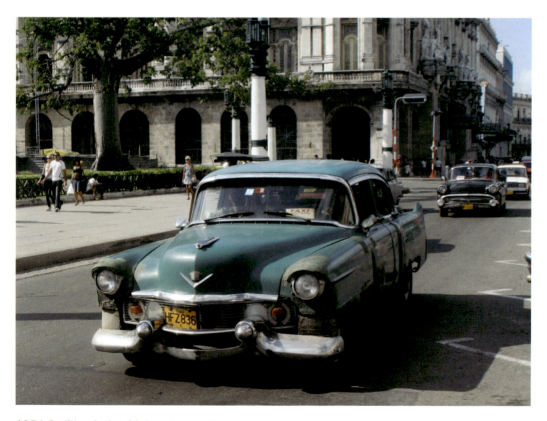
1954 Cadillac Series 62 four-door sedan.

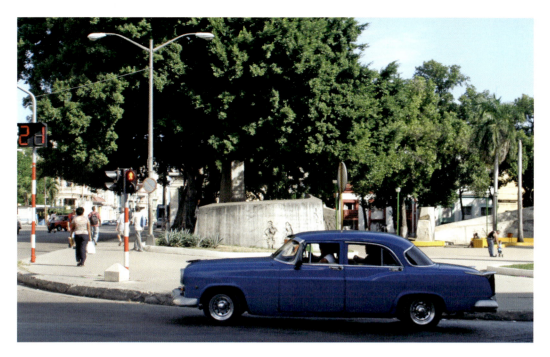

1955 Chrysler Windsor four-door sedan.

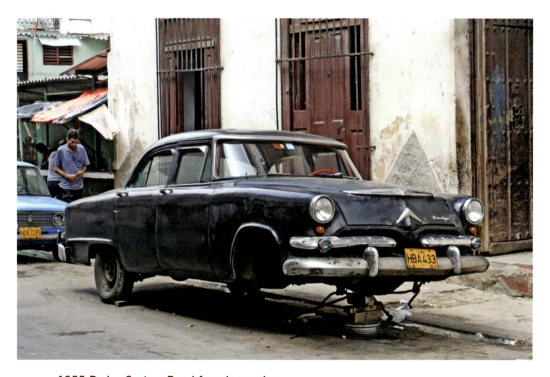

1955 Dodge Custom Royal four-door sedan.

1955 DeSoto four-door sedan.

1955 Ford Fairlane Town sedan.

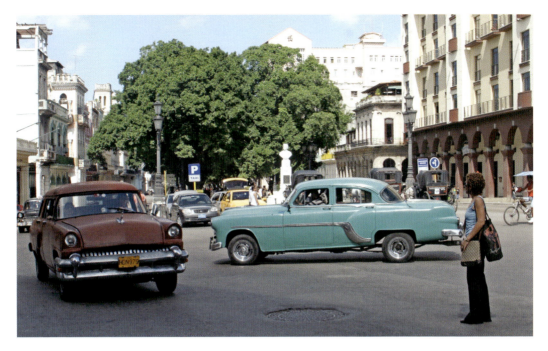

1955 Mercury Station Wagon (left) and a 1954 Pontiac Star Chief (right).

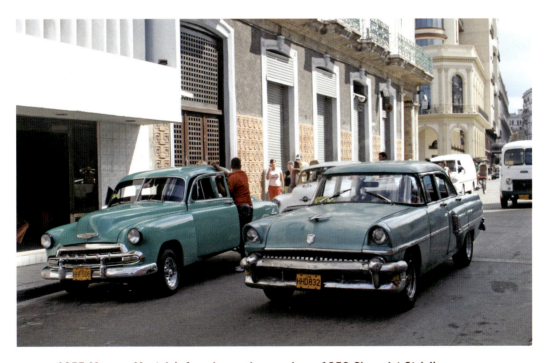

1955 Mercury Montclair four-door sedan passing a 1952 Chevrolet Styleline.

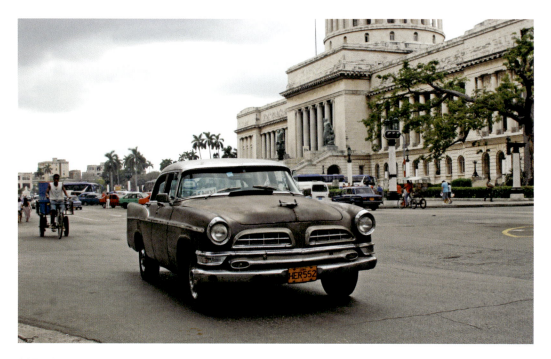

1955 Chrysler New Yorker DeLuxe four-door sedan.

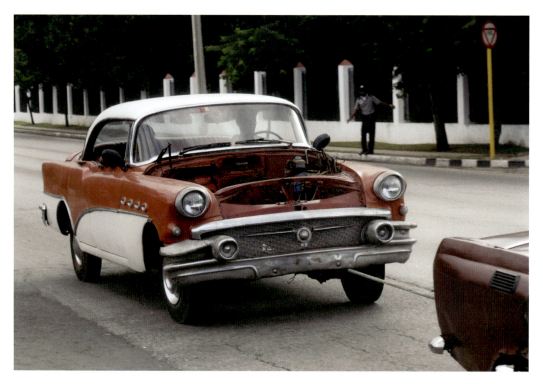

1955 Buick Series 70 Roadmaster Riviera hardtop coupe being towed.

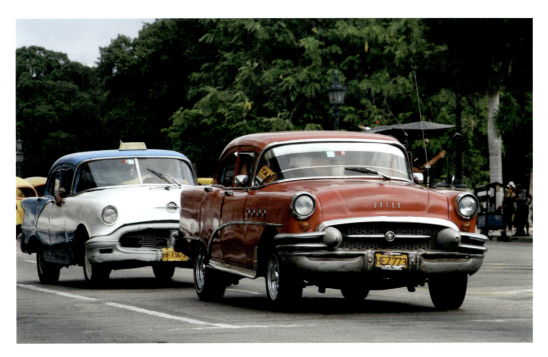

1955 Buick Series 70 Roadmaster Riviera hardtop sedan and a 1956 Oldsmobile Super 88 Holiday hardtop sedan.

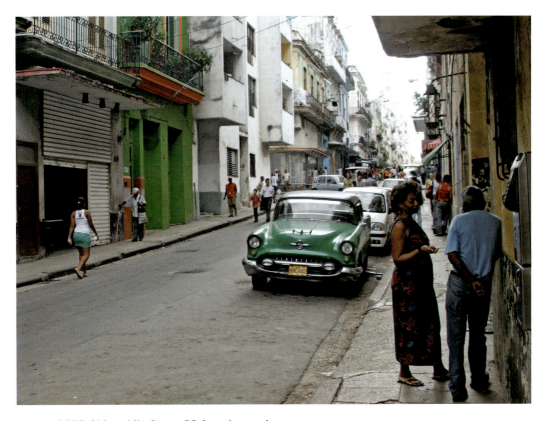

1955 Oldsmobile Super 88 four-door sedan.

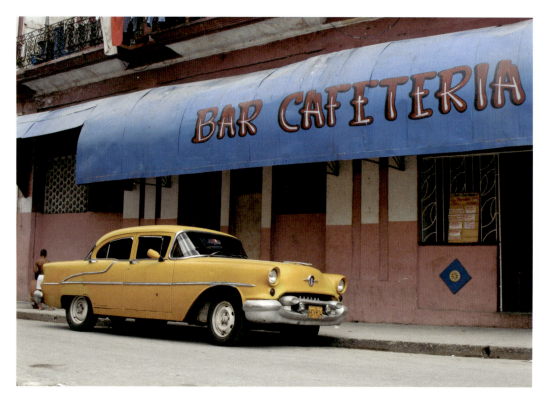

1955 Oldsmobile Super 88 four-door sedan.

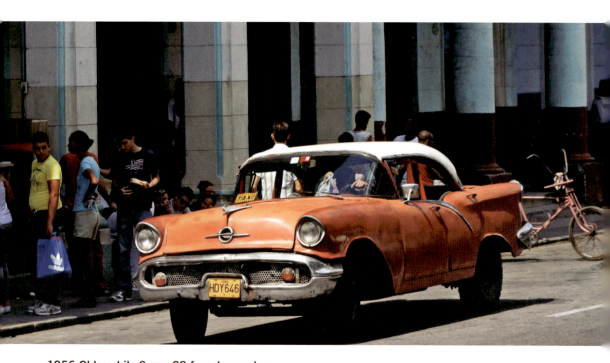

1956 Oldsmobile Super 88 four-door sedan.

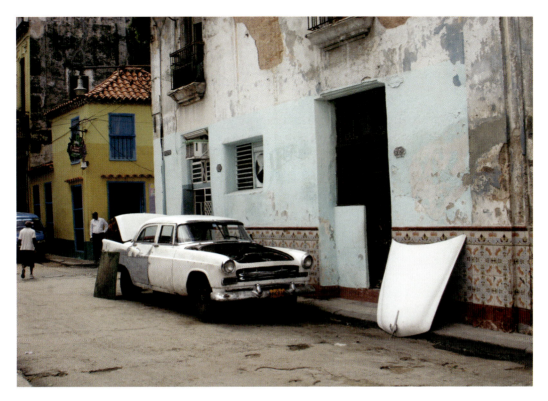
1956 Chrysler New Yorker four-door sedan.

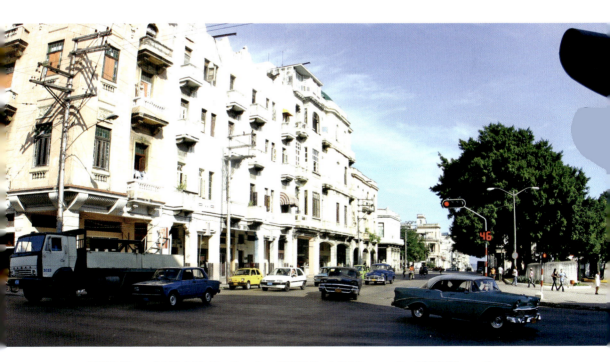
1956 Chevrolet Bel Air Sport sedan, 1958 Ford Fairlane and a 1953 Plymouth.

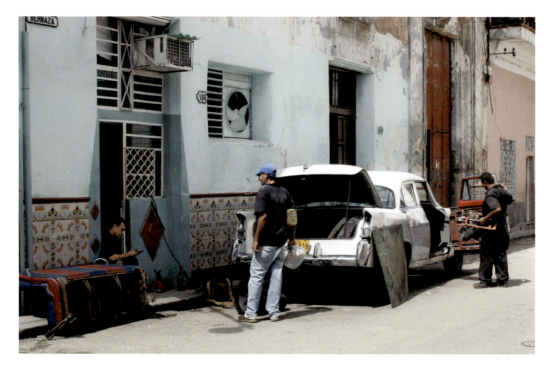
1956 Chrysler New Yorker four-door sedan.

1956 Buick convertible coupe.

1956 Dodge D-63-1 V8 convertible coupe.

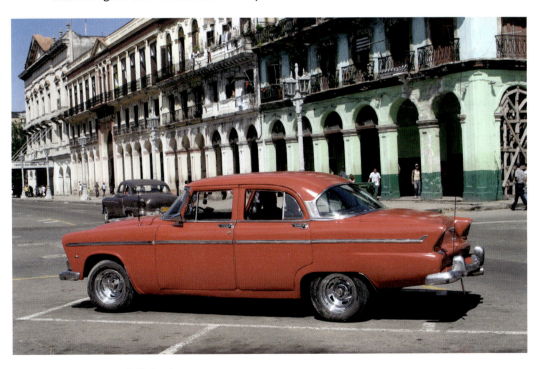

1955 Plymouth Belvedere.

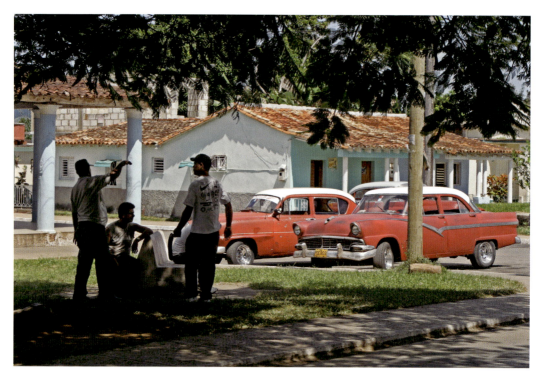

1956 Ford Fairlane four-door sedan and a 1954 Plymouth four-door sedan.

1956 Ford Fairlane Club two-door sedan.

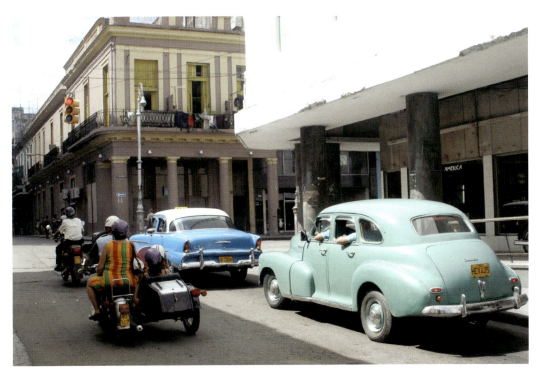
1940s Chrysler Series C36N New Yorker and a 1955 De Soto Fireflite Coronado 4-door sedan.

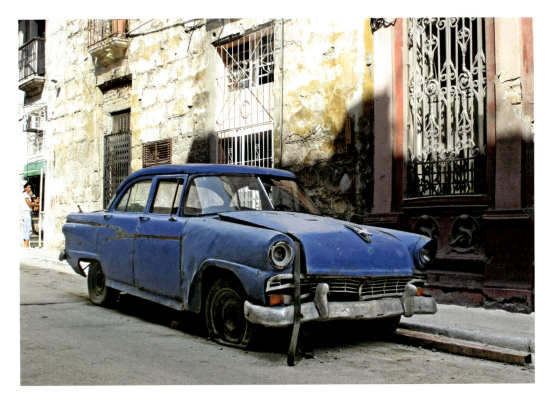
1956 Ford Fairlane Town sedan.

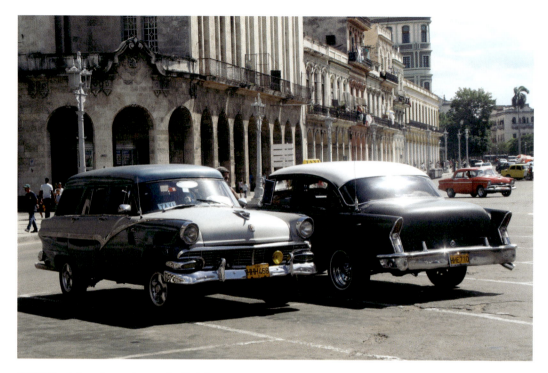

1956 Ford Country sedan and a Buick.

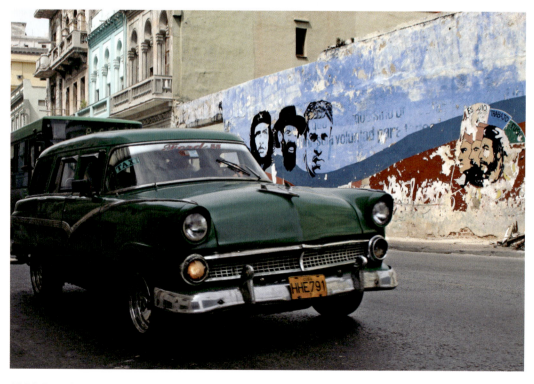

1956 Ford Station Wagon.

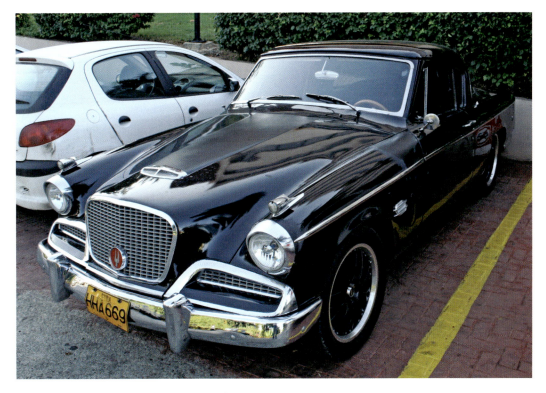
1956 Studebaker Golden Hawk Coupe.

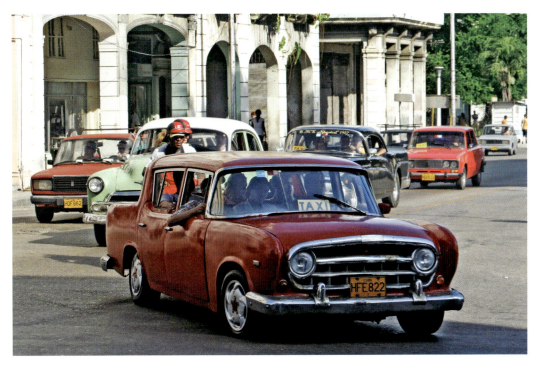
1956 Nash Rambler four-door sedan.

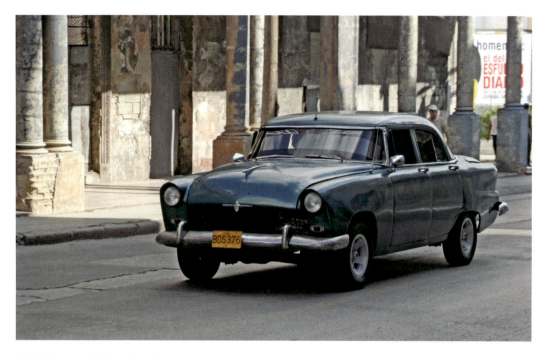

1956 Plymouth Plaza four-door sedan.

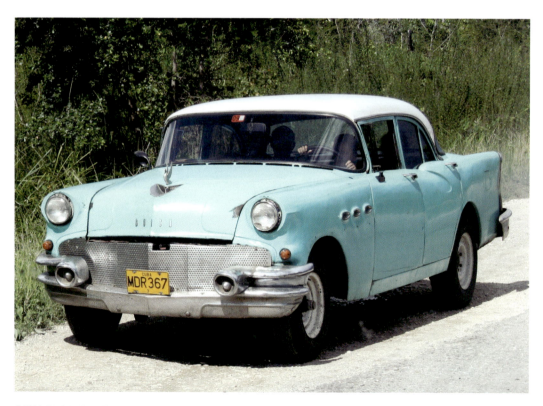

1956 Buick Special Riviera hardtop sedan.

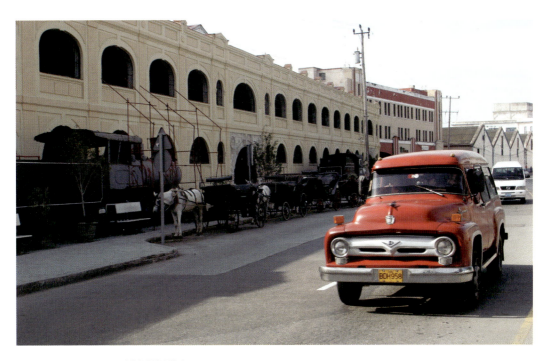

1956 Ford F100 V8 Pickup.

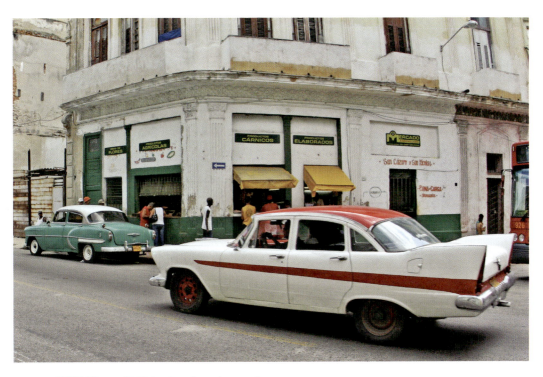

1957 Plymouth Belvedere four-door sedan.

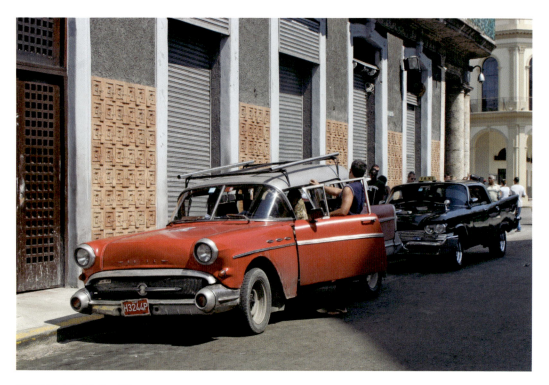

1957 Buick Station Wagon.

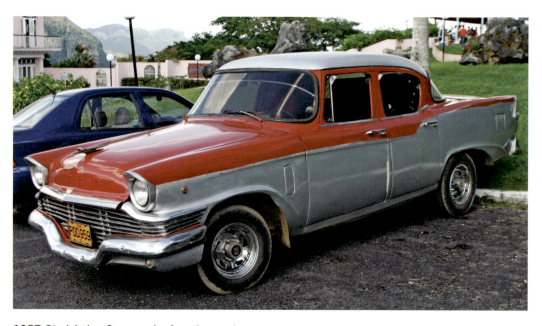

1957 Studebaker Commander four-door sedan.

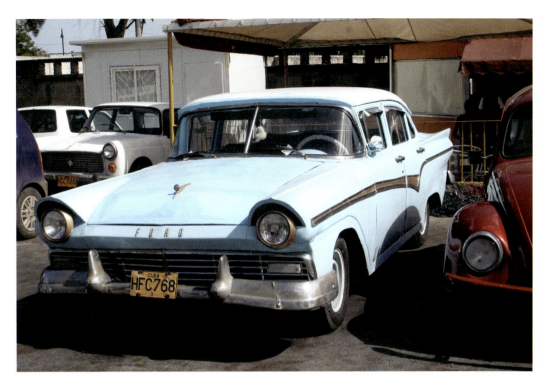

1957 Ford Custom 300 Tudor sedan.

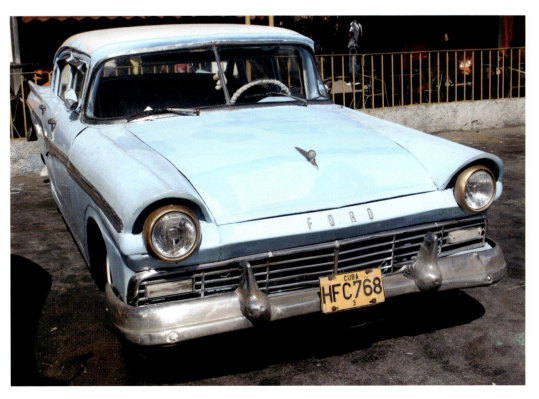

1957 Ford Custom 300 Tudor sedan.

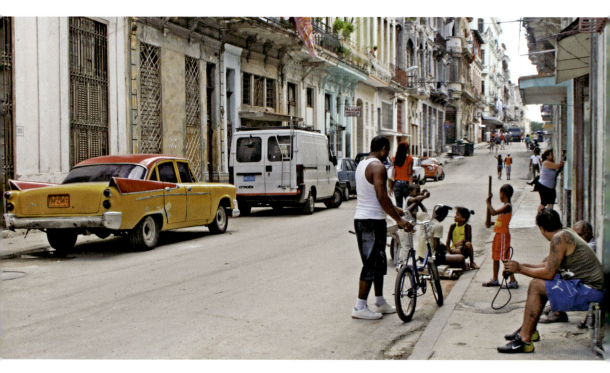

1957 Dodge Custom Royal four-door sedan.

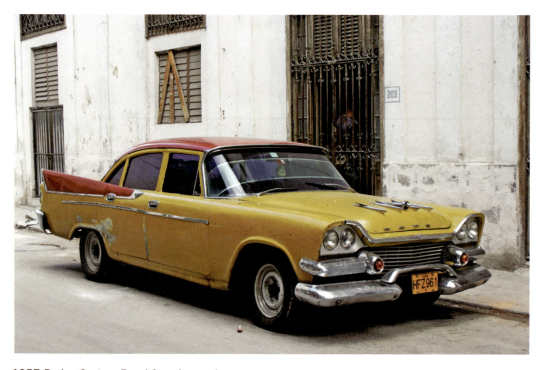

1957 Dodge Custom Royal four-door sedan.

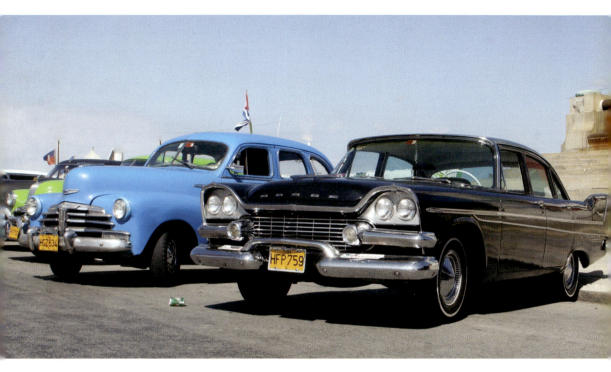

1957 Dodge and 1948 Chevrolet Fleetmaster four-door sedan.

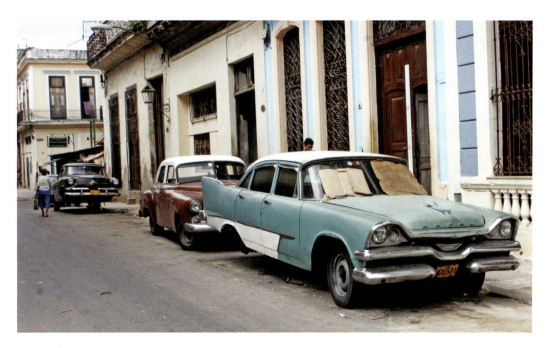

1957 Dodge.

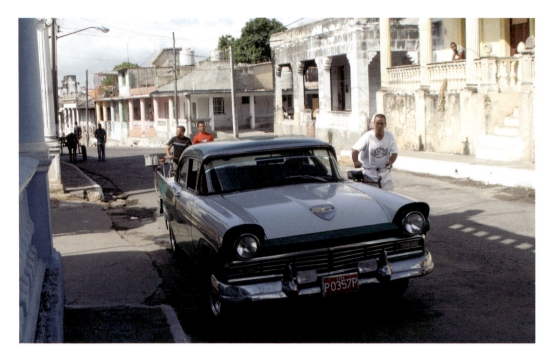

1957 Ford Fairlane two-door coupe.

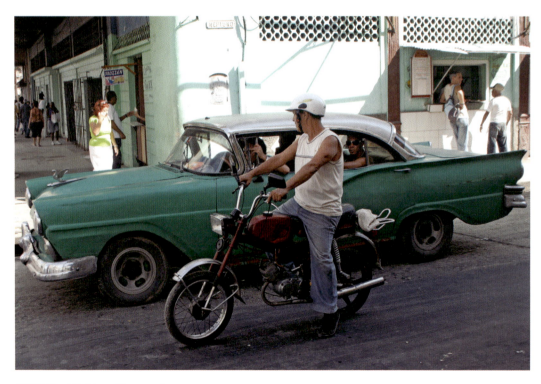

1957 Ford Fairlane Town sedan.

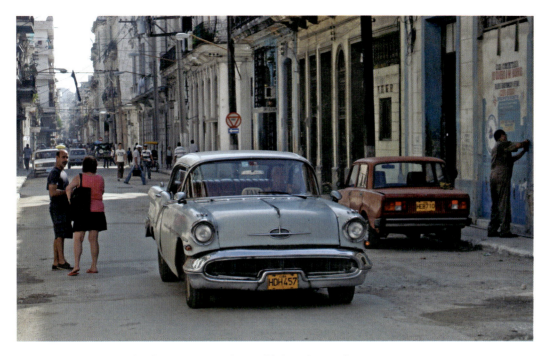

1957 Oldsmobile Golden Rocket Super 88 four-door sedan.

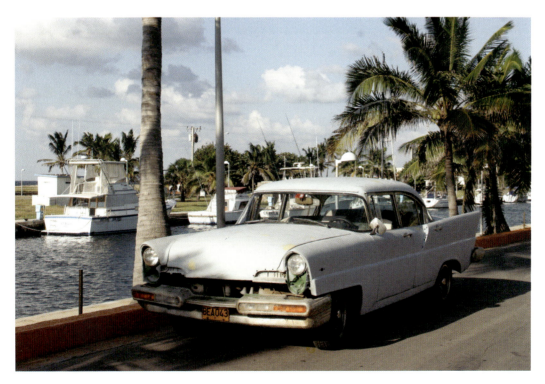

1957 Lincoln four-door sedan.

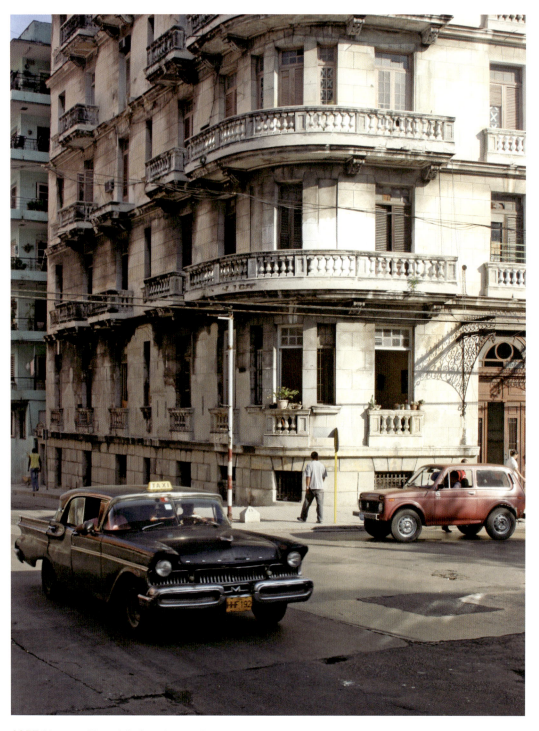

1957 Mercury Montclair four-door sedan.

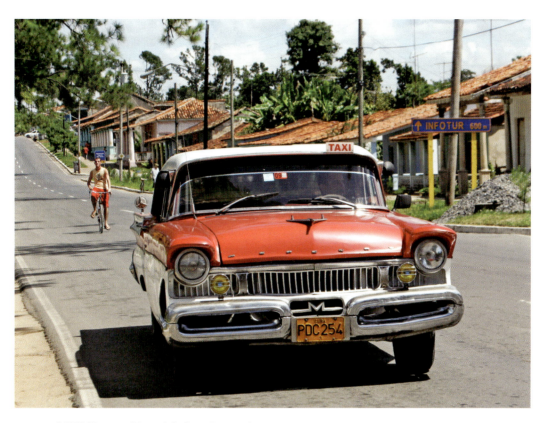

1957 Mercury Montclair four-door sedan.

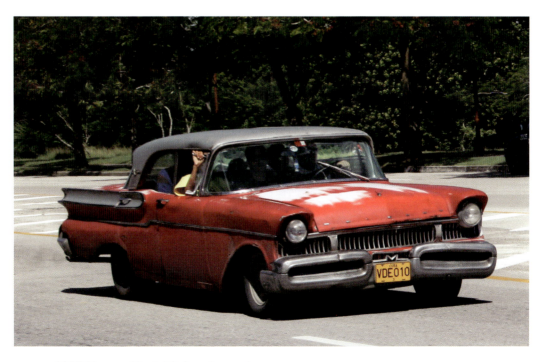

1957 Mercury Montclair four-door sedan.

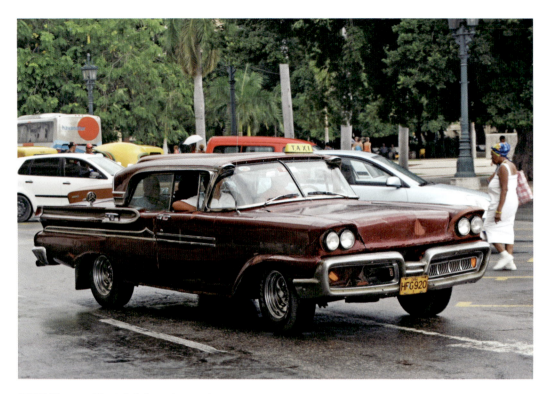

1957 Mercury Montclair four-door sedan.

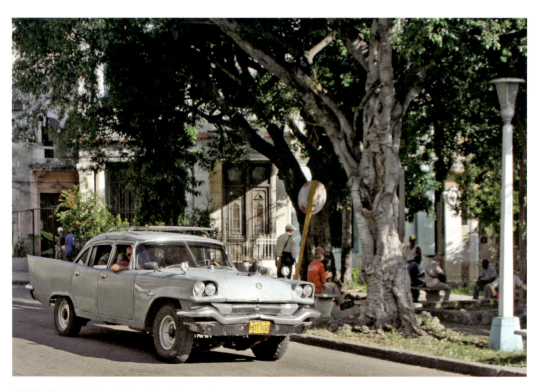

1957 Chrysler New Yorker four-door sedan.

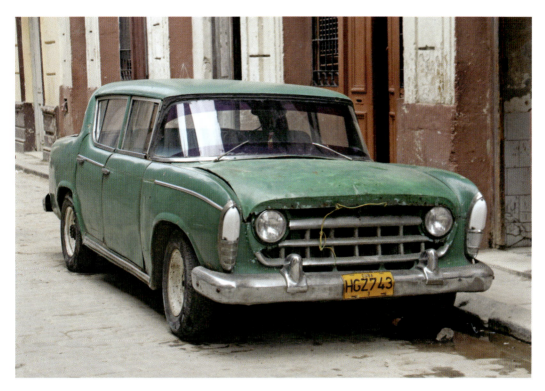

1957 Nash Rambler four-door sedan.

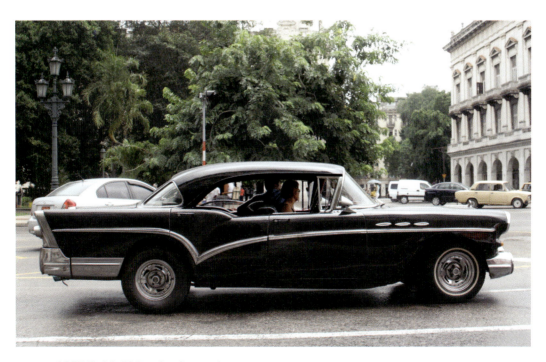

1957 Buick Riviera hardtop sedan.

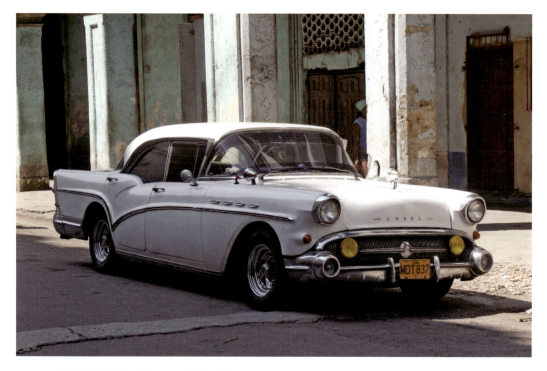

1957 Buick Roadmaster Riviera four-door sedan.

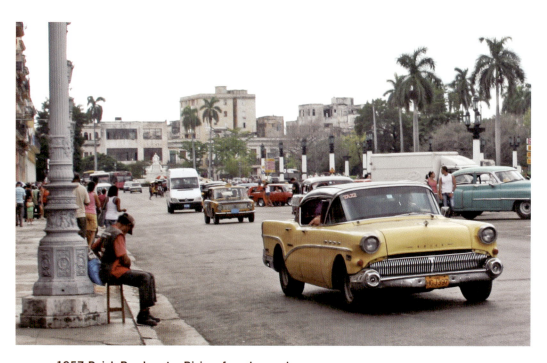

1957 Buick Roadmaster Riviera four-door sedan.

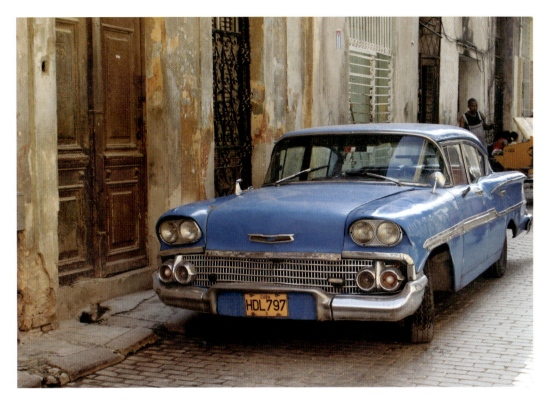

1958 Chevrolet Biscayne four-door sedan.

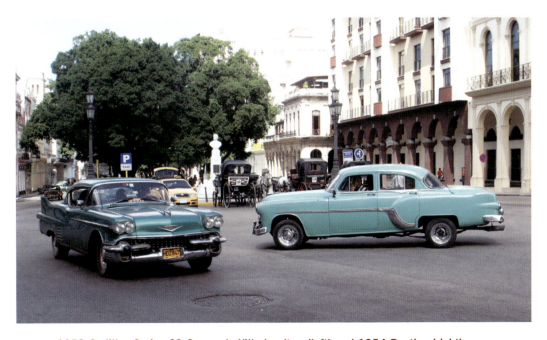

1958 Cadillac Series 62 Coupe de Ville hardtop (left) and 1954 Pontiac (right).

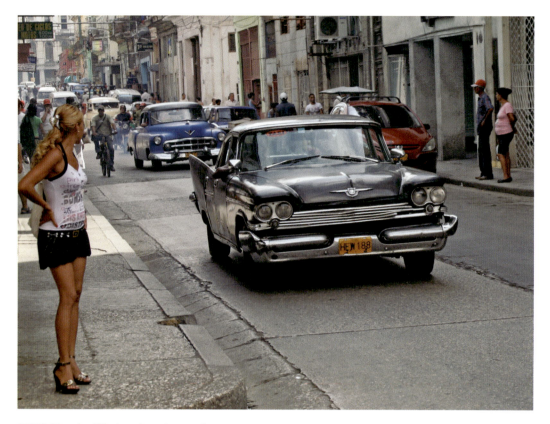

1958 Chrysler Windsor four-door sedan.

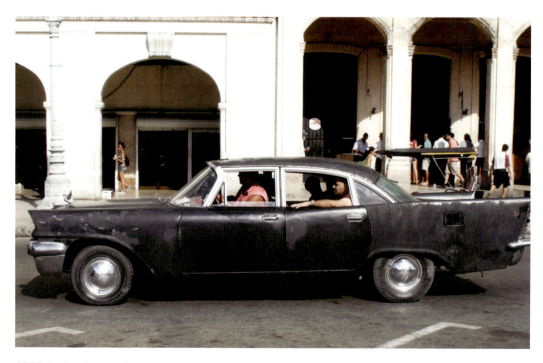

1958 Dodge Coronet four-door sedan.

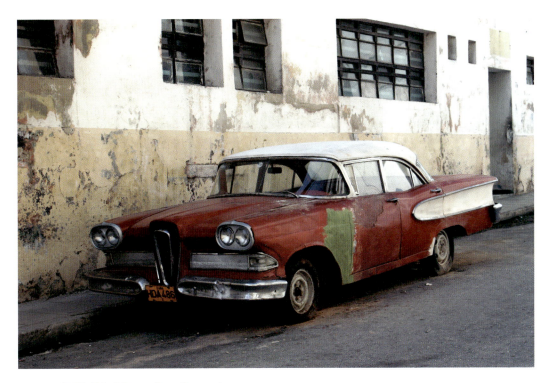
1958 Edsel Pacer four-door sedan.

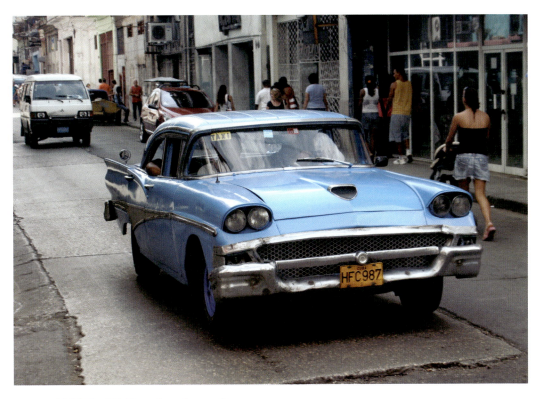
1958 Ford Fairlane four-door sedan.

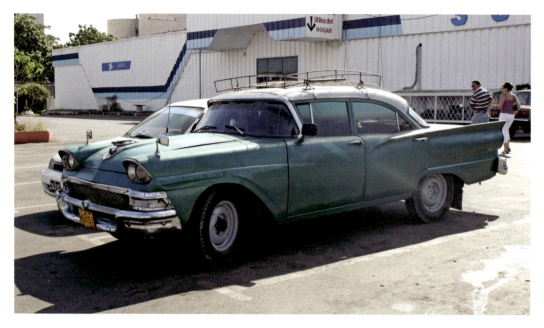

1958 Ford Fairlane four-door sedan.

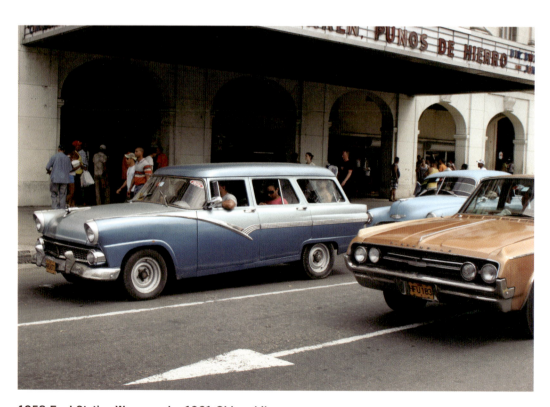

1958 Ford Station Wagon and a 1961 Oldsmobile.

1958 Rambler Ambassador Custom four-door sedan.

1958 Rambler Custom four-door sedan.

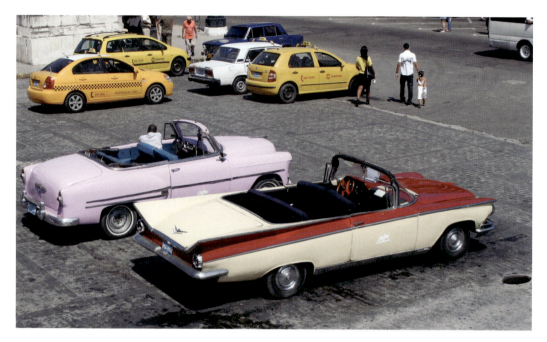

1959 Buick Elektra convertible coupe and a 1954 Chevrolet Bel Air convertible coupe.

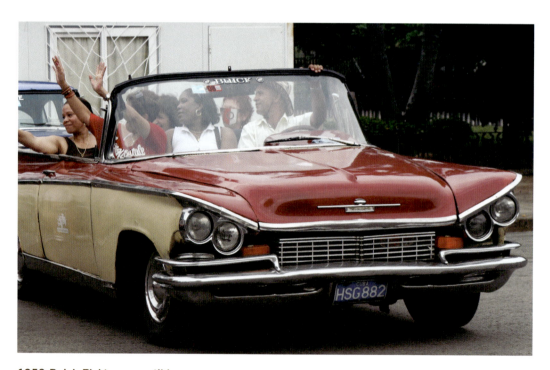

1959 Buick Elektra convertible coupe.

The interior of a 1959 Buick Elektra convertible coupe.

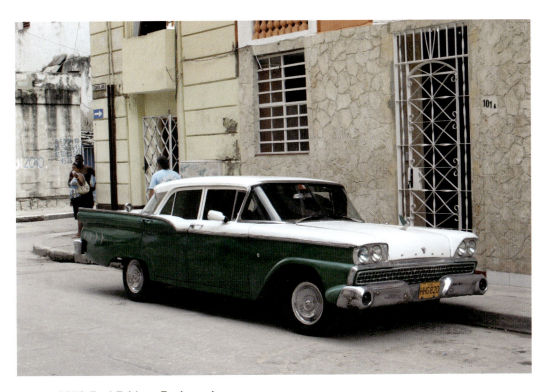
1959 Ford Fairlane Fordor sedan.

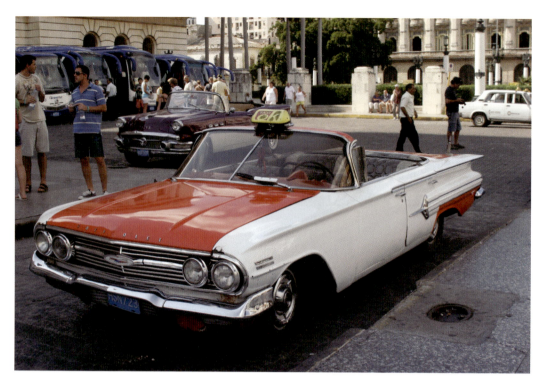
1960 Chevrolet Impala convertible and a 1956 Buick convertible coupe.

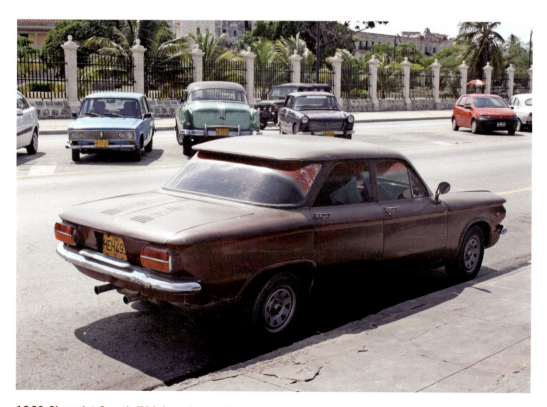
1960 Chevrolet Corvair 700 four-door sedan.

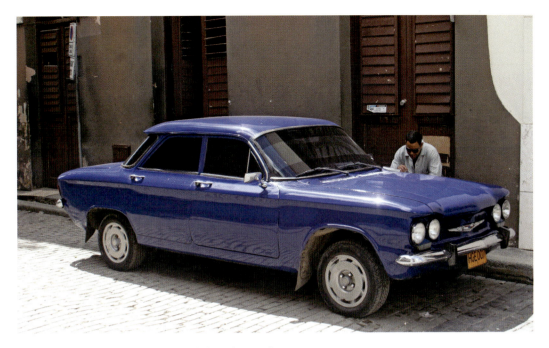

1960 Chevrolet Corvair 700 four-door sedan.

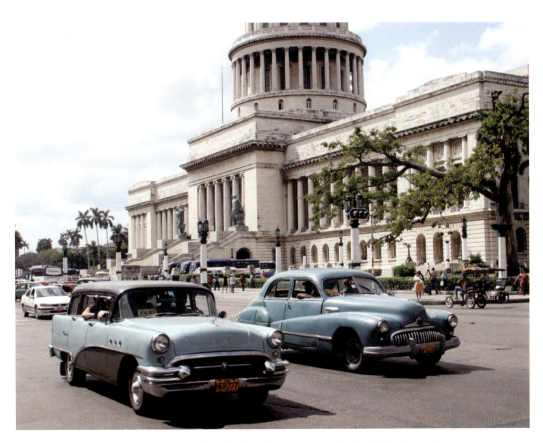

Buick 1955 Series 49 four-door Station Wagon and a 1946 Buick Super four-door sedan.

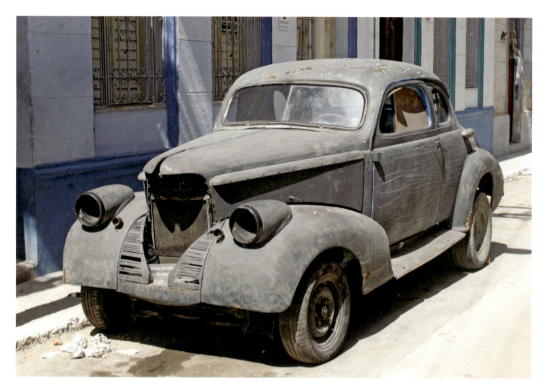

1937 Ford Model 78 coupe.

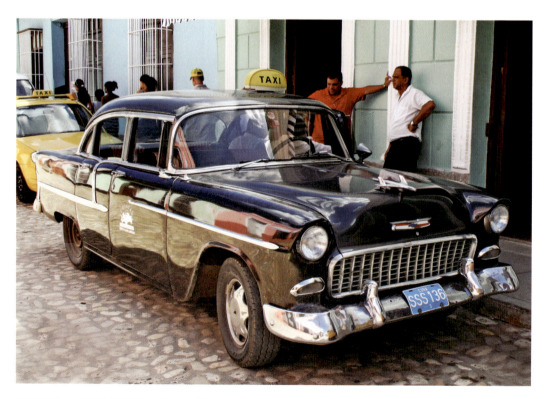

1955 Chevrolet Bel Air four-door sedan.

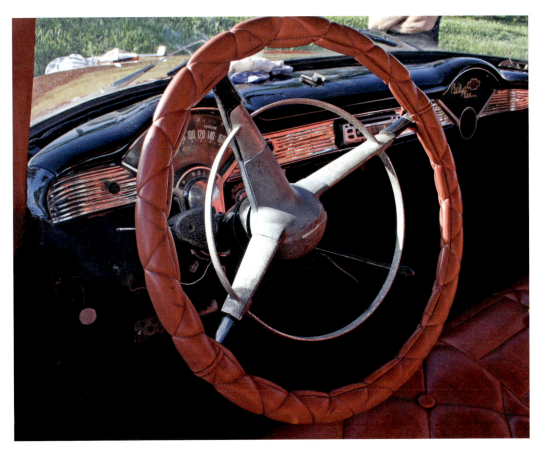
The interior of a 1956 Chevrolet Bel Air four-door sedan.

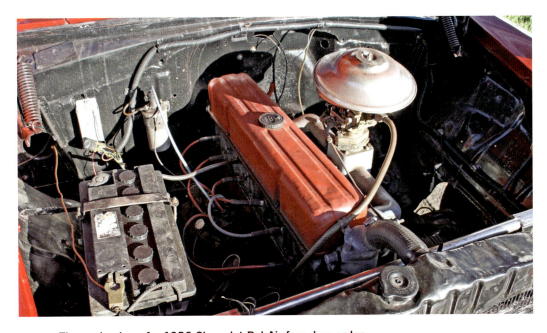
The engine bay of a 1956 Chevrolet Bel Air four-door sedan.

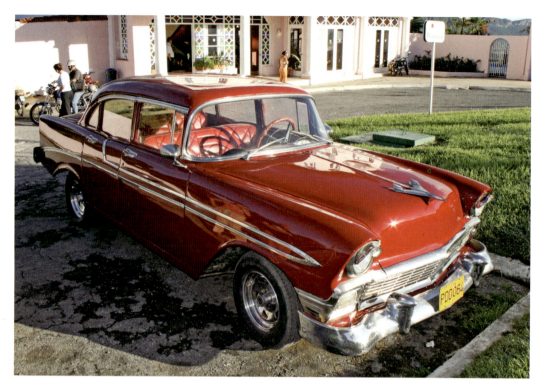

1956 Chevrolet Bel Air four-door sedan.

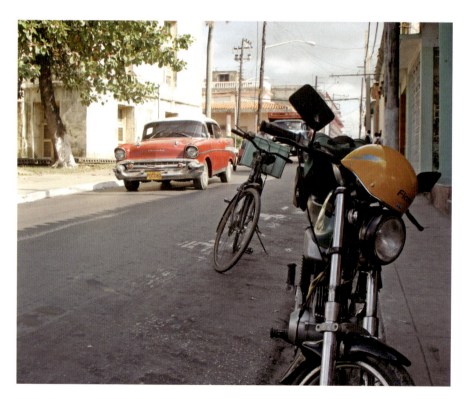

1957 Chevrolet Bel Air four-door sedan.

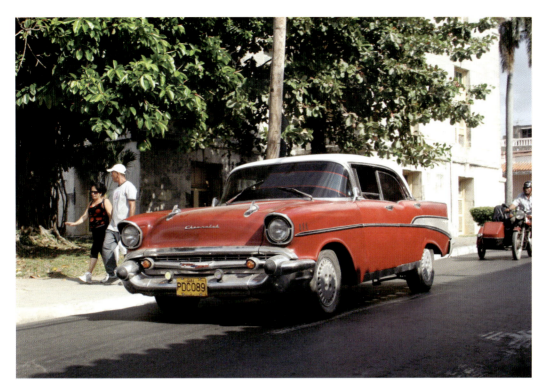

1957 Chevrolet Bel Air four-door sedan.

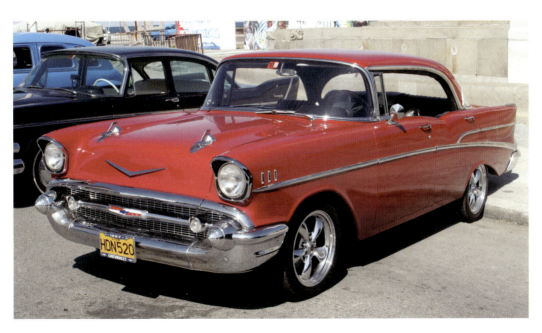

1957 Chevrolet Bel Air four-door sedan.

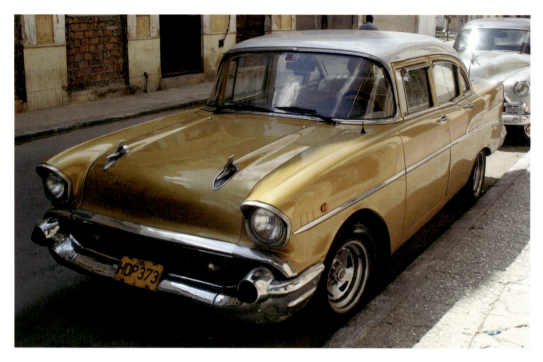
1957 Chevrolet Bel Air four-door sedan.

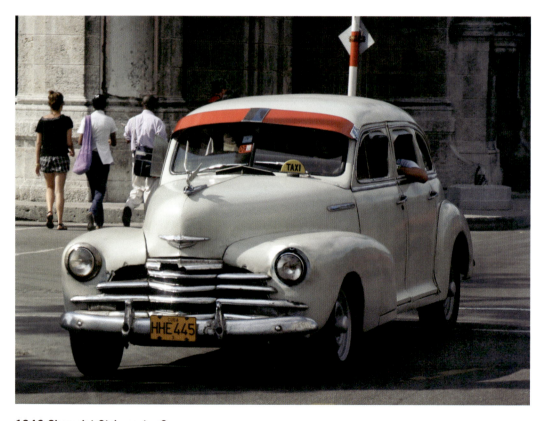
1946 Chevrolet Stylemaster 2.

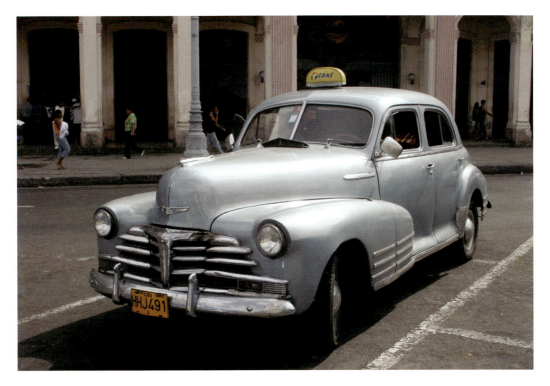

1946 Chevrolet Stylemaster 2.

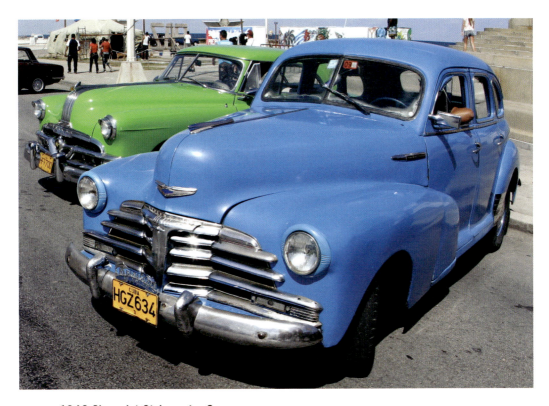

1946 Chevrolet Stylemaster 2.

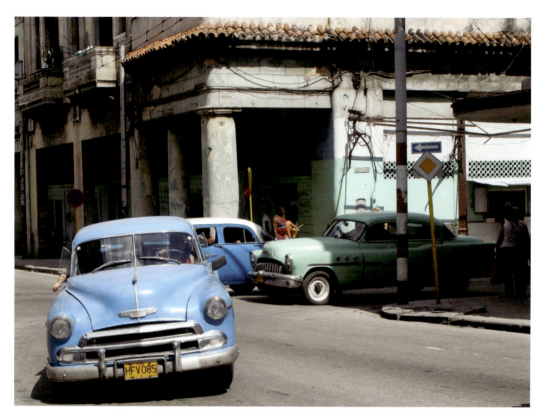

1950 Chevrolet Stylemaster.

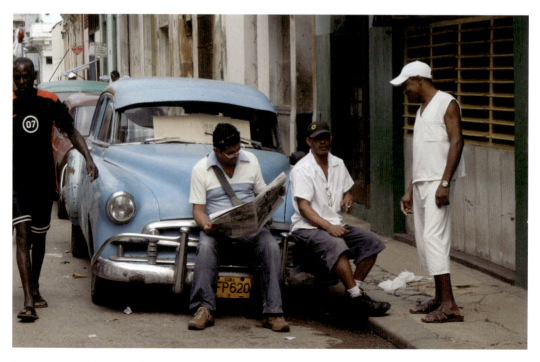

1950 Chevrolet Stylemaster.

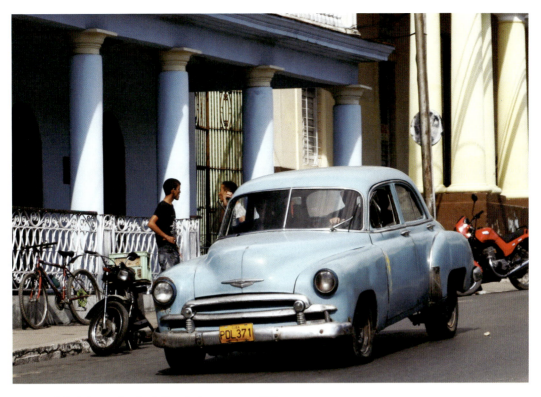
1950 Chevrolet Styleline DeLuxe convertible coupe.

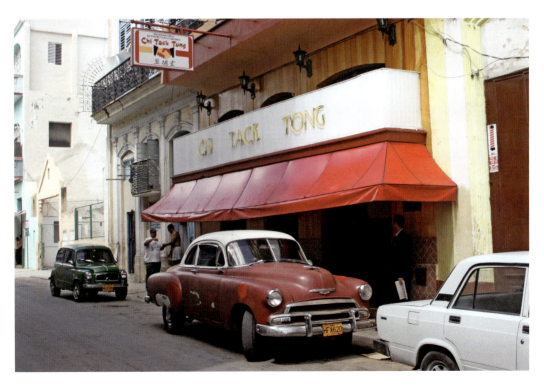
1952 Chevrolet.

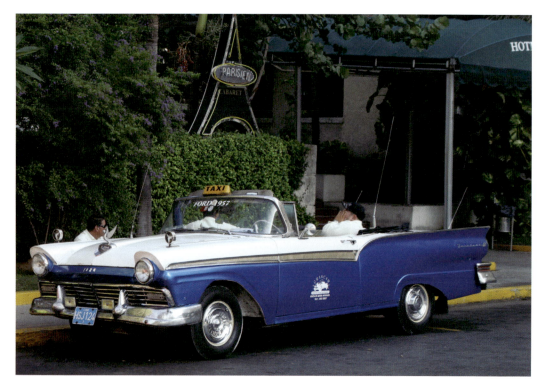
1957 Ford Fairlane 500 Sunliner convertible coupe

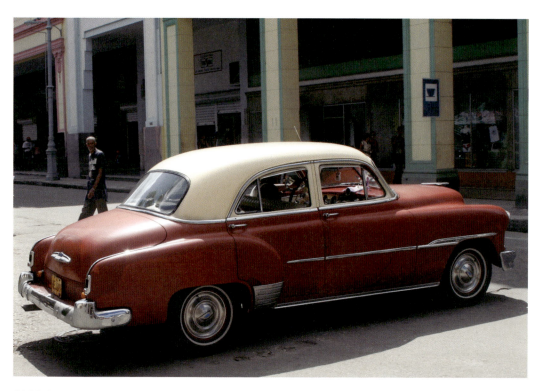
1952 Chevrolet.

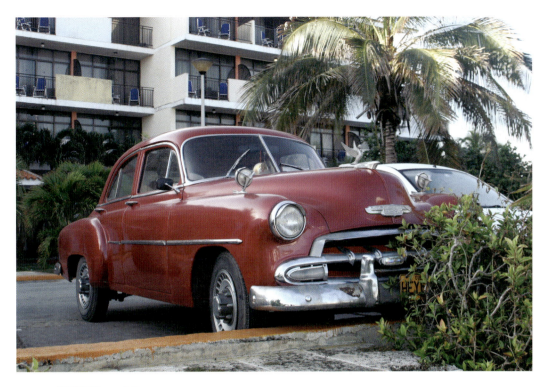

1952 Chevrolet.

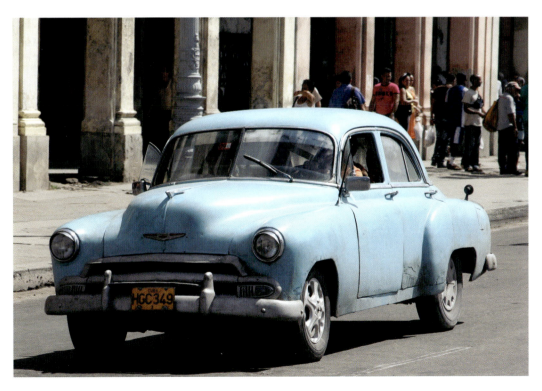

1952 Chevrolet.

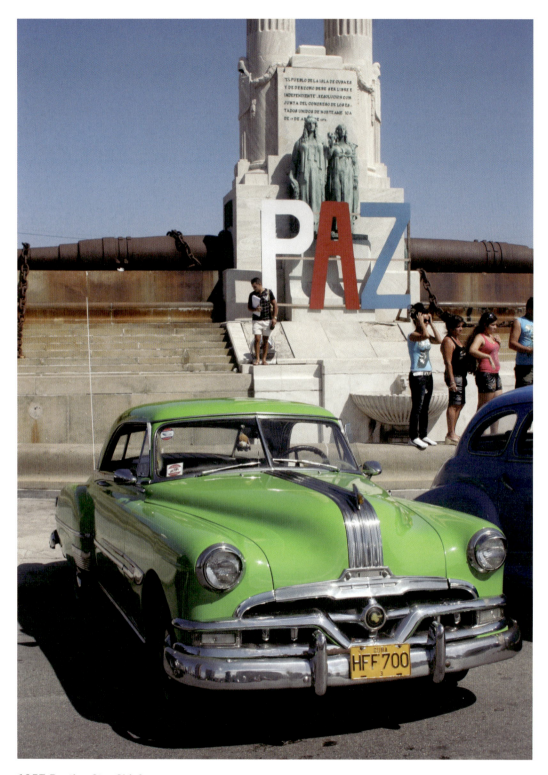
1957 Pontiac Star Chief.

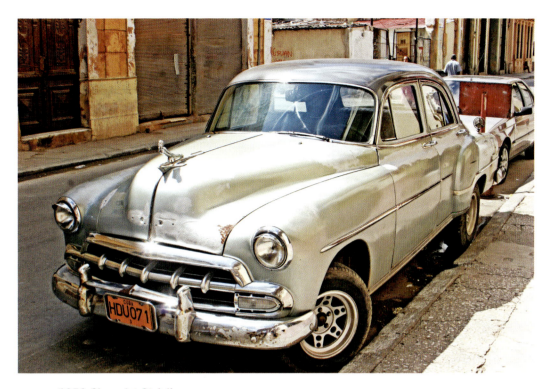
1952 Chevrolet Styleline.

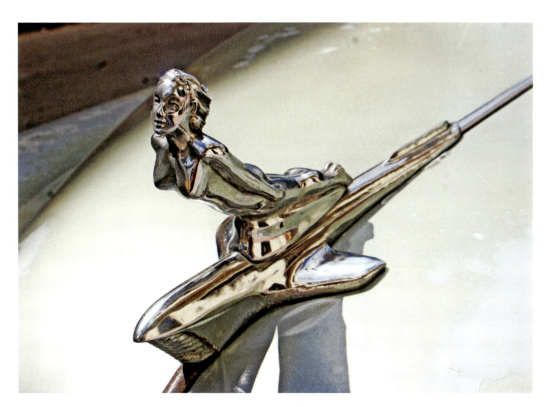
The hood ornament of a 1952 Chevrolet Styleline.

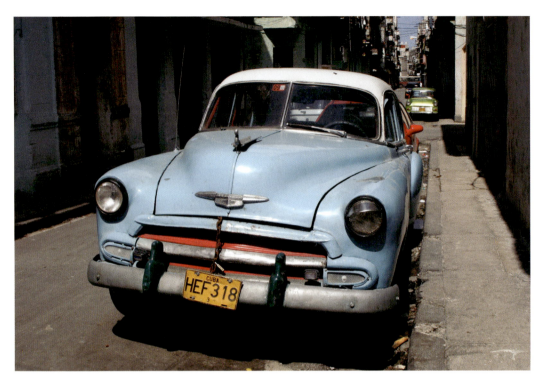

1952 Chevrolet Styleline.

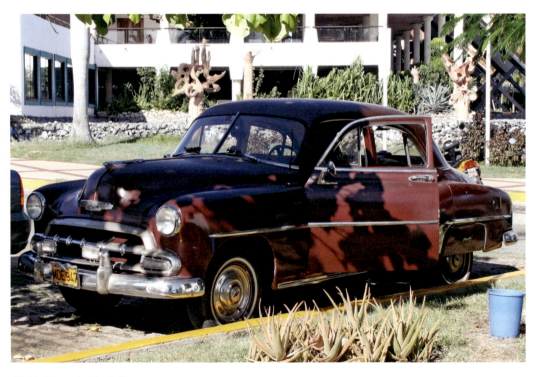

1952 Chevrolet Styleline.

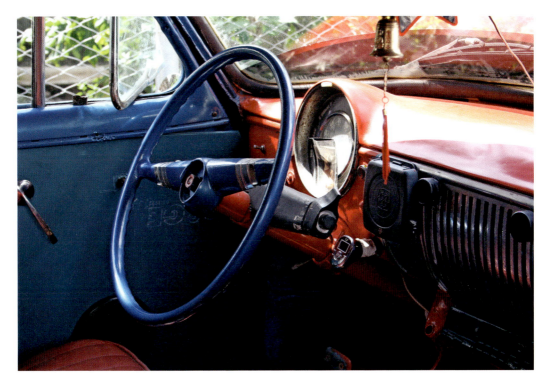
The interior of a 1952 Chevrolet Styleline DeLuxe four-door sedan.

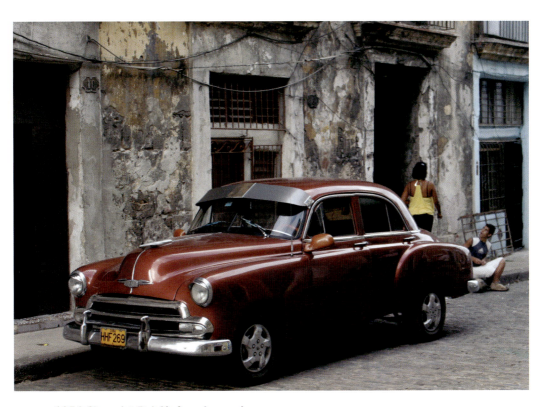
1954 Chevrolet Bel Air four-door sedan.

1954 Chevrolet Bel Air four-door sedan.

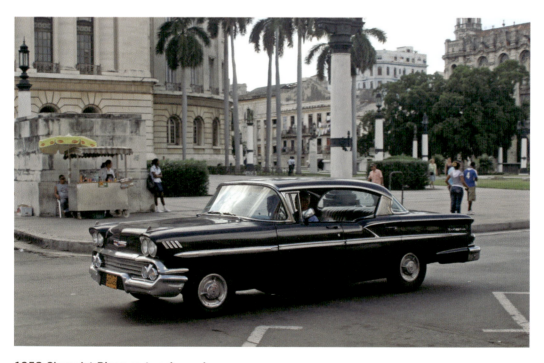

1958 Chevrolet Biscayne two-door saloon.

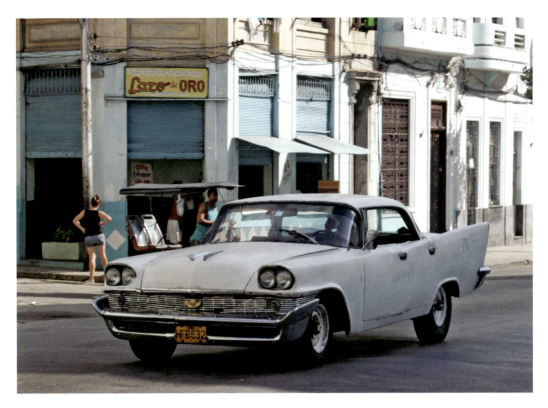
1958 Chrysler New Yorker sedan.

1955 DeSoto Fireflite convertible.

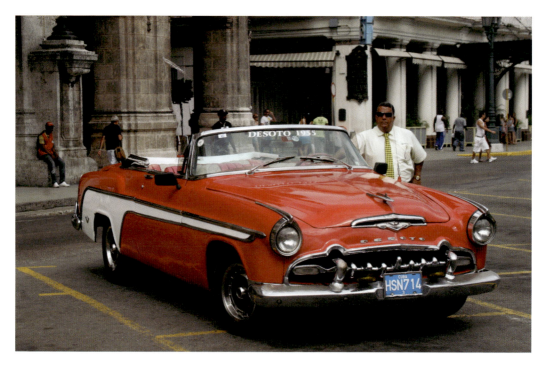

1955 DeSoto Fireflite convertible.

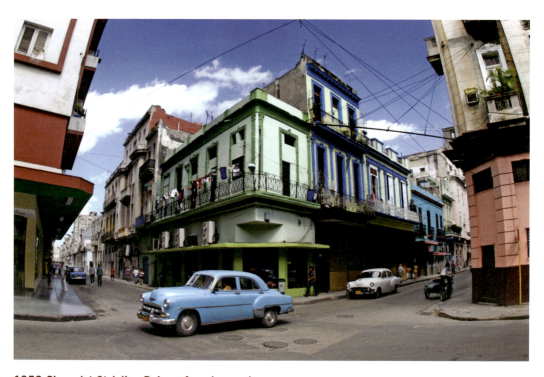

1952 Chevrolet Styleline DeLuxe four-door sedan.

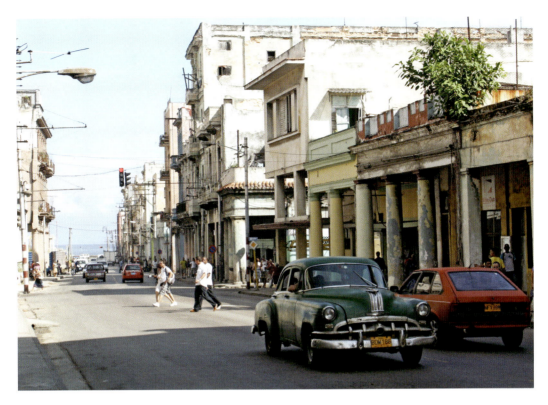
1950 Pontiac Chieftain Eight.

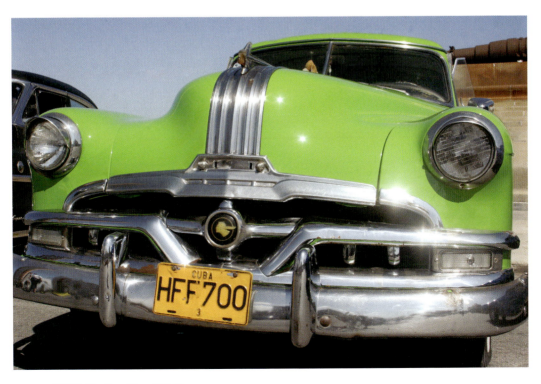
1953 Pontiac Star Chief.

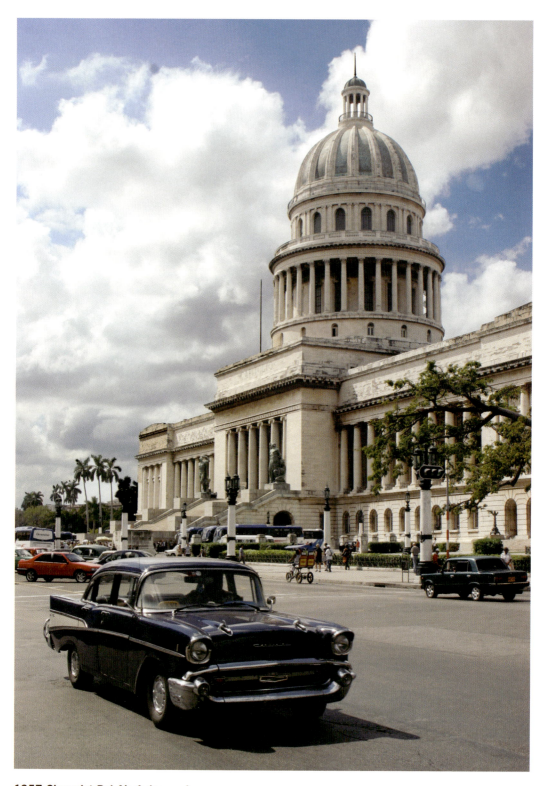

1957 Chevrolet Bel Air 4-door sedan.

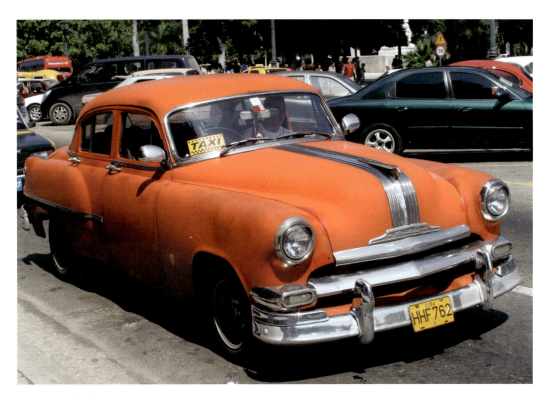

1957 Pontiac Star Chief.

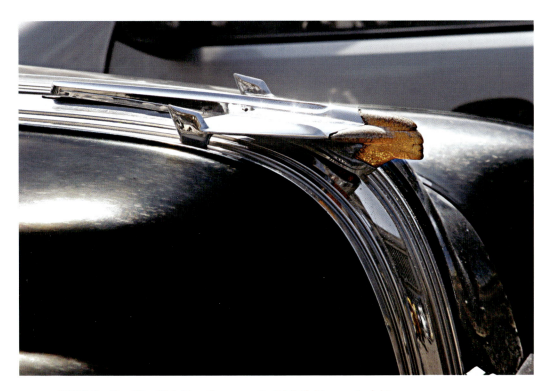

1957 Pontiac Star Chief hood ornament which lights up at night.

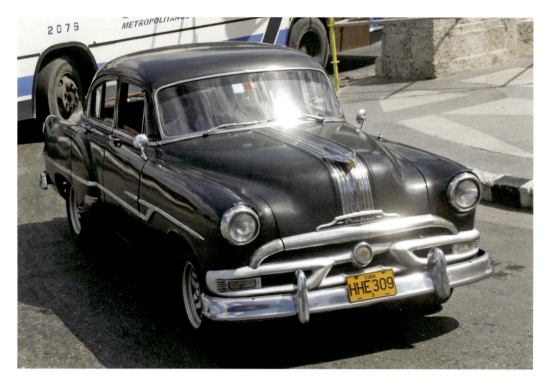

1957 Pontiac Star Chief.

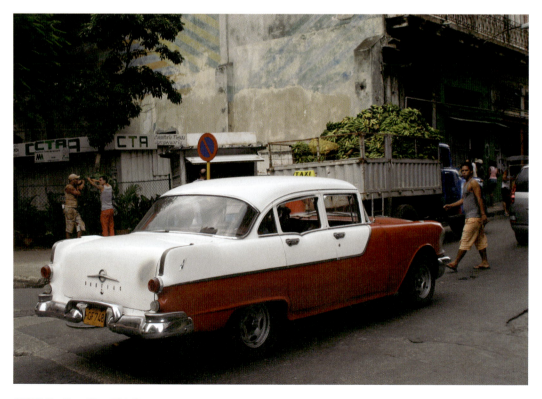

1957 Pontiac Star Chief.

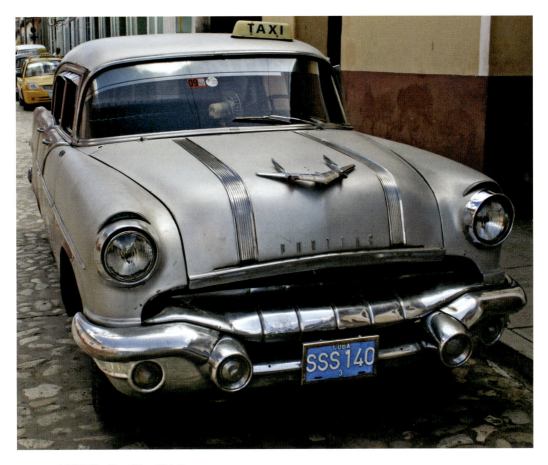
1957 Pontiac Star Chief.

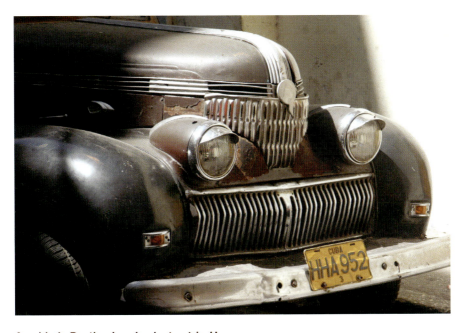
An elderly Pontiac in a back street in Havana.

Willys Aero.

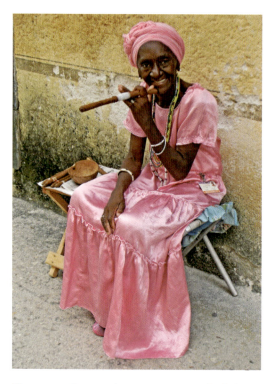
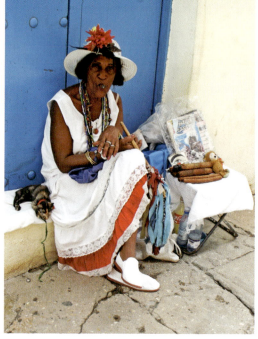

Cigars are also popular among women in Cuba.

EUROPEAN CLASSICS

1955 Simca Aronde saloon.

Austin A40 Somerset.

Ford Consul.

Ford Consul.

Ford Consul.

Ford Consul.

Intended as a 'people's car', Lada's history can be traced back to the 1960s as a joint venture between Russia and Italy.

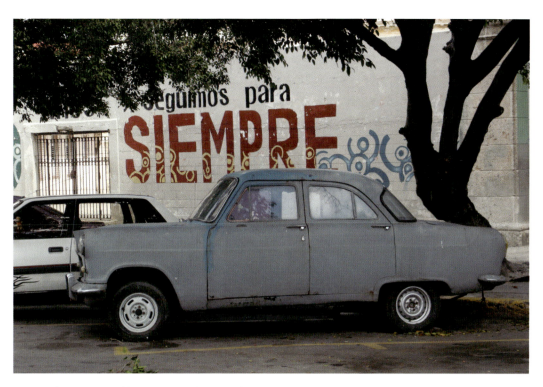

Colourful graffiti – Para Siempre: 'Forever' – adorns a brick wall behind a Ford Consul.

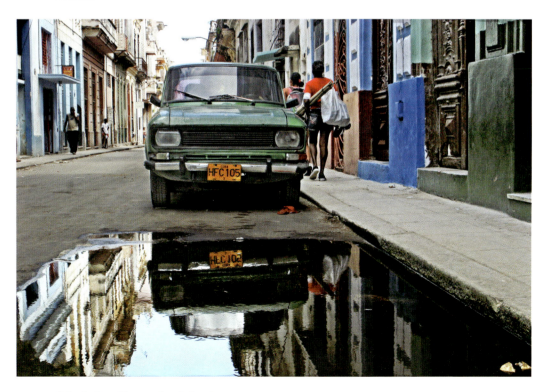

A Lada in a Havana backstreet.

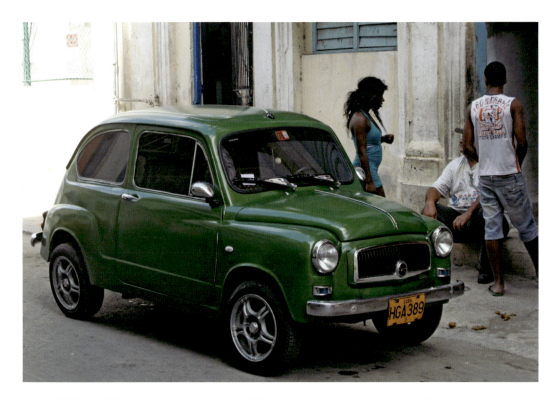

Above and left: **Fiat 600.**

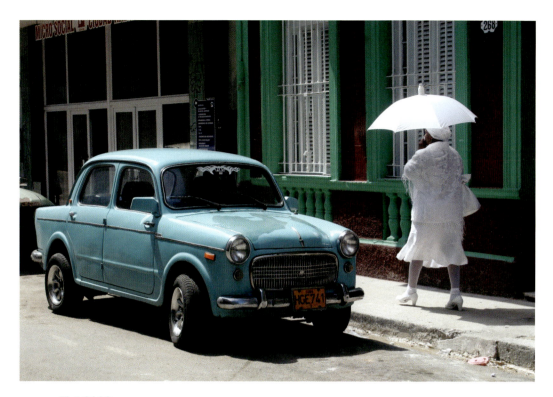
Fiat 1100.

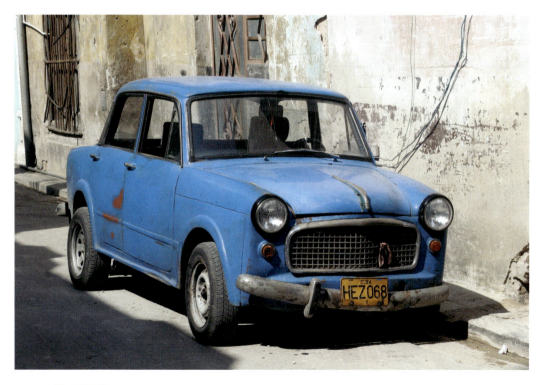
Fiat 1100.

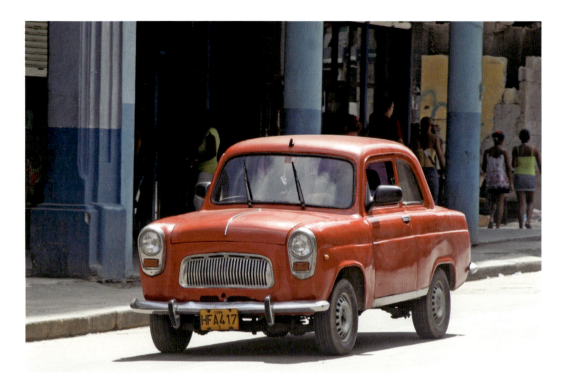
Ford 103E.

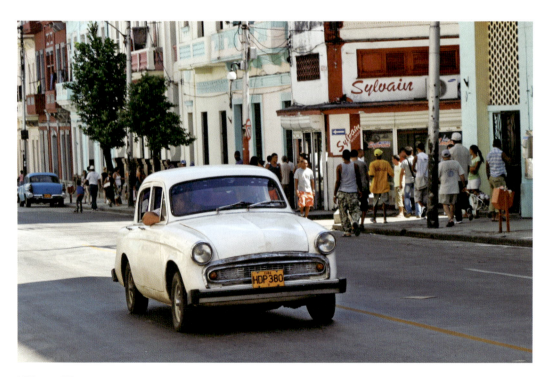
Hillman Minx.

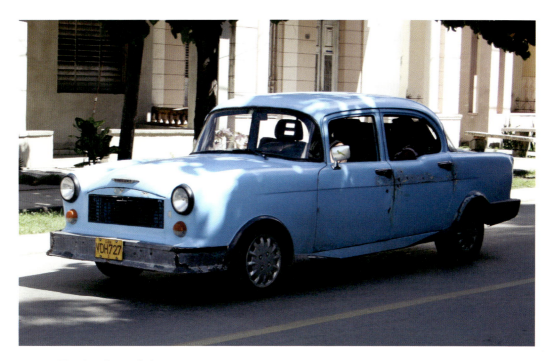
Humber Super Snipe.

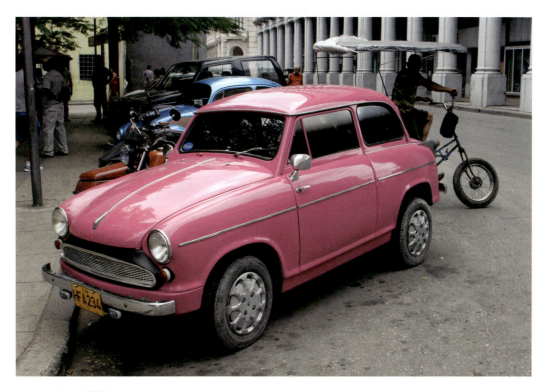
Lloyd 600.

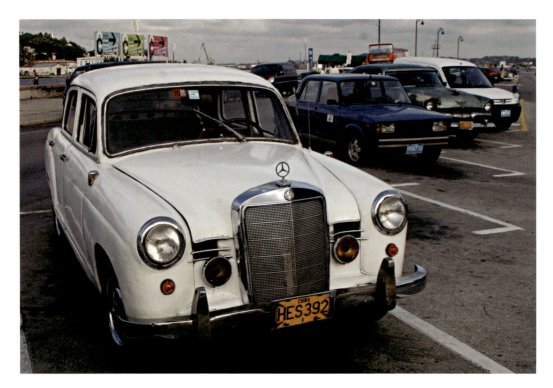

Mercedes 180.

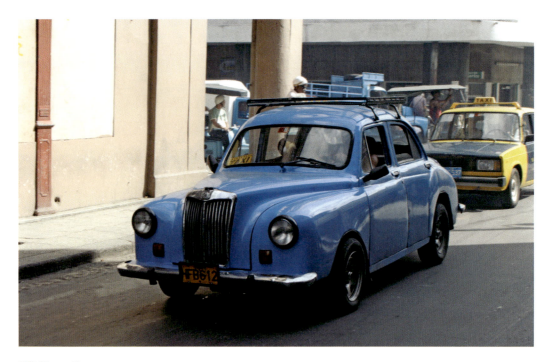

MG Magnette.

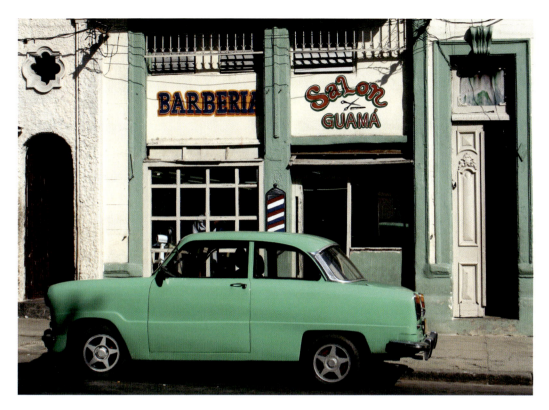

Ford Taunus 12M.

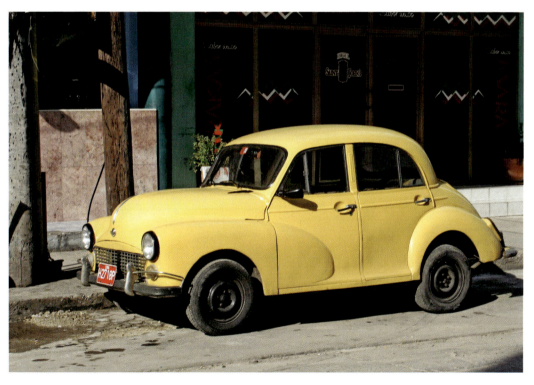

Morris Minor.

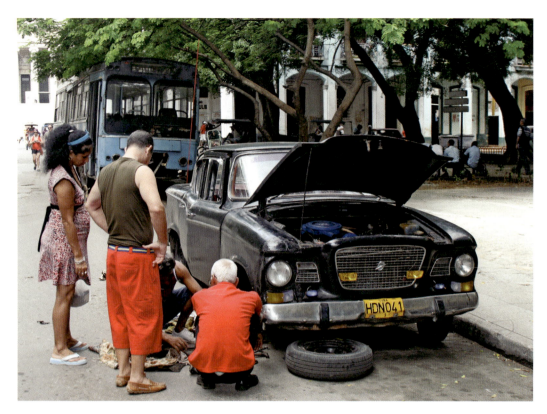

Opel (1960 4D Studebaker Lark).

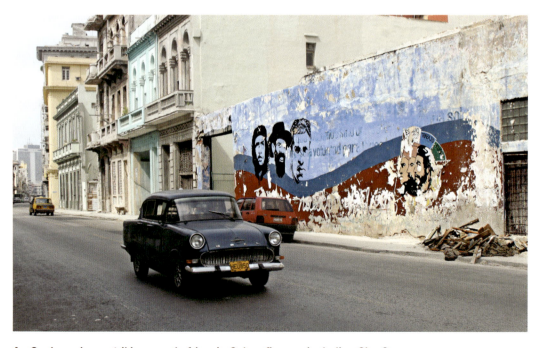

An Opel passing a striking mural of iconic Cuban figures, including Che Guevara.

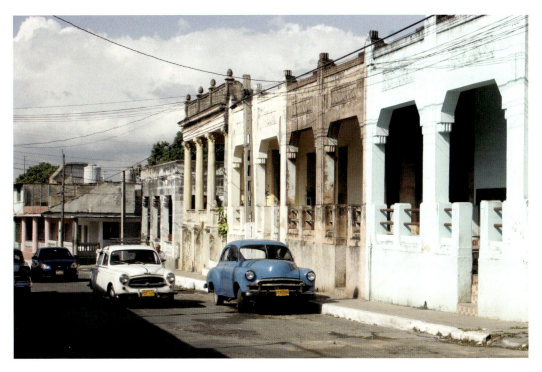
Peugeot 403 and a 1950 Chevrolet Styleline.

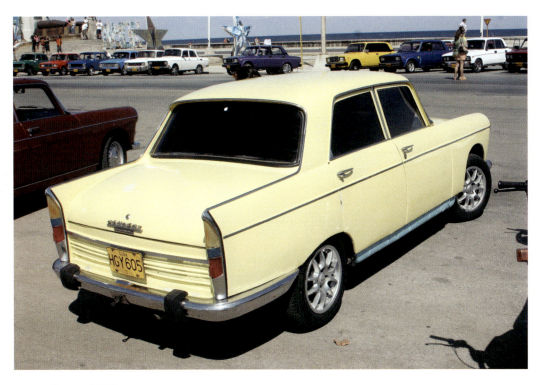
Peugeot 404.

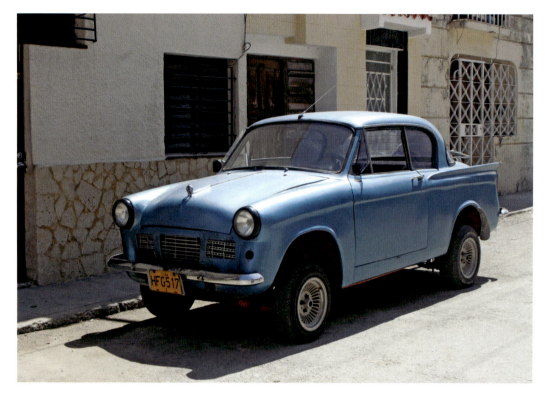

Sunbeam Rapier.

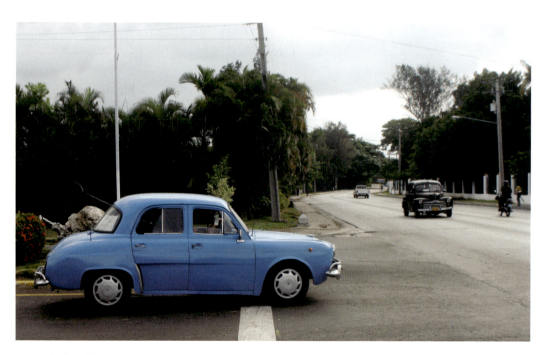

Renault Dauphine.

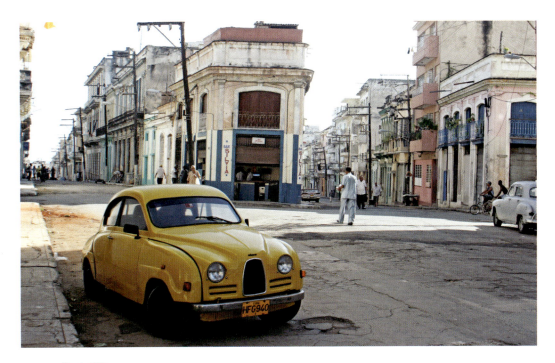
Saab 93.

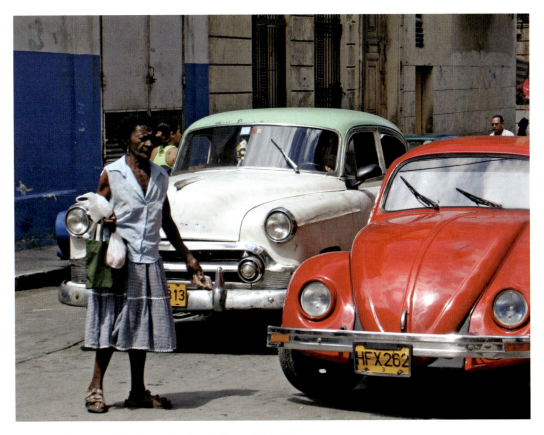
Volkswagen Beetle and a 1953 Chevrolet Styleline.

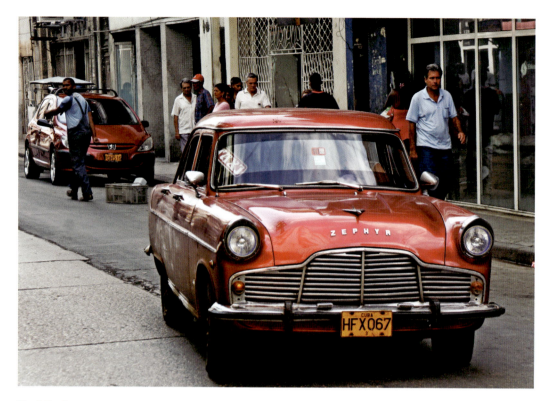
Ford Zephyr.

Ford Zephyr Six.

HAVANA SIGHTS AND CITY LIGHTS

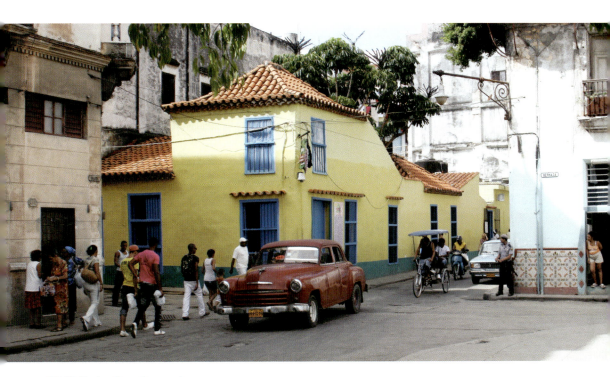

1949 Dodge four-door sedan.

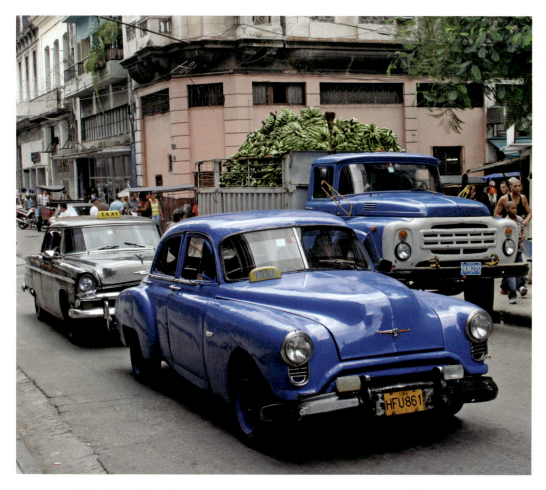

1949 Oldsmobile Futuramic 98 four-door sedan tailed by a 1955 Plymouth Belvedere.

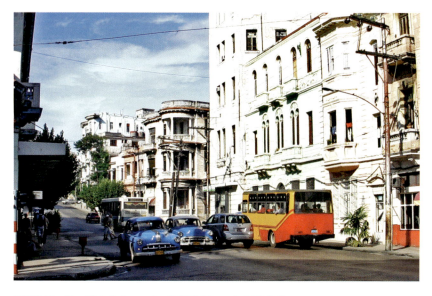

1950 Pontiac Chieftain and a 1953 Chevrolet Styleline.

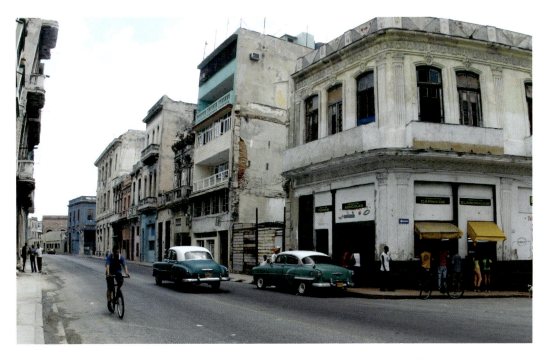
1951 Chevrolet Styleline DeLuxe Bel Air hardtop in typical downtown Havana.

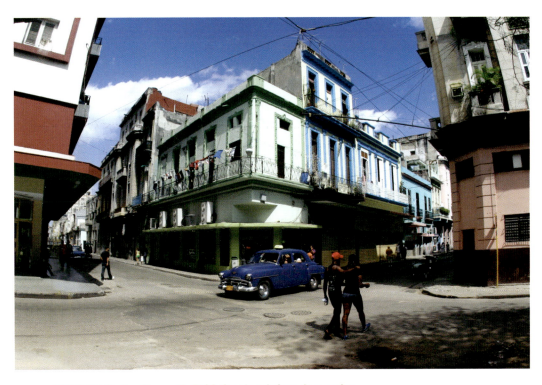
1951-52 Series Plymouth P-23 Cranbrook four-door sedan.

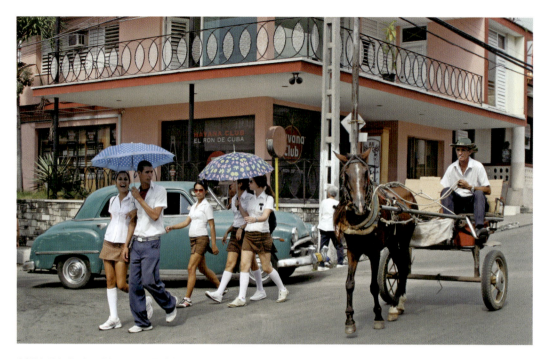
1951-52 Series Plymouth P-23 Cranbrook four-door sedan.

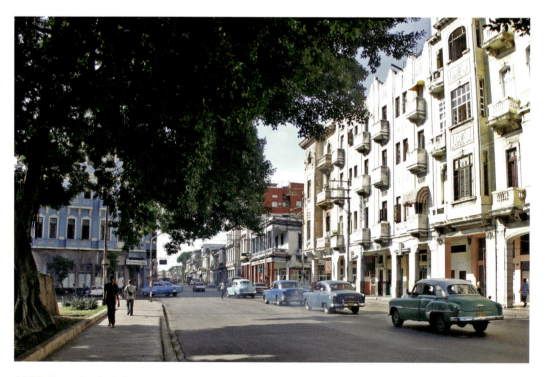
1952 Chevrolet Styleline.

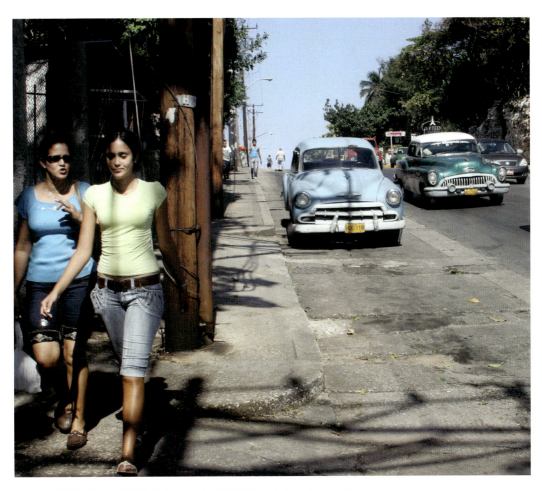
1952 Chevrolet Styleline and a 1953 Buick four-door sedan.

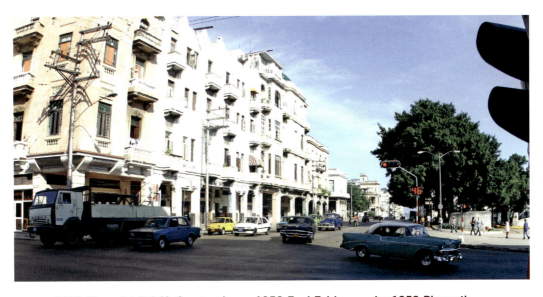
1956 Chevrolet Bel Air Sport sedan, a 1958 Ford Fairlane and a 1953 Plymouth.

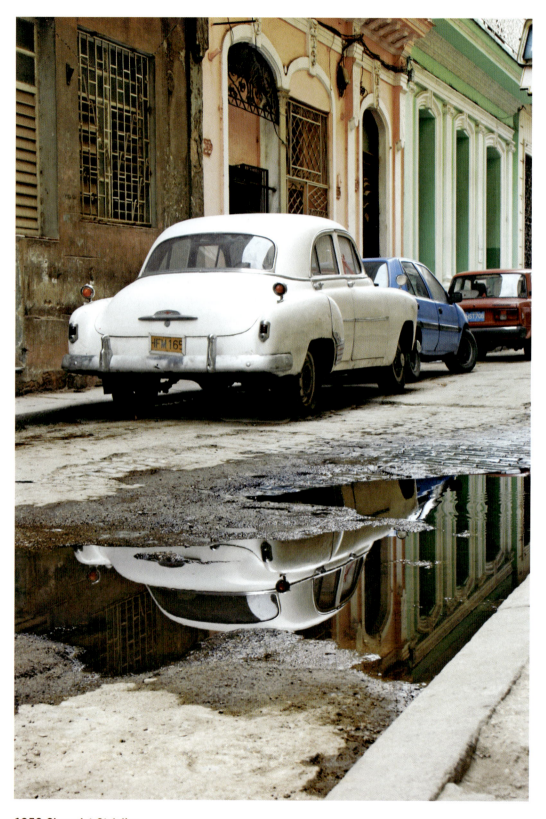

1952 Chevrolet Styleline.

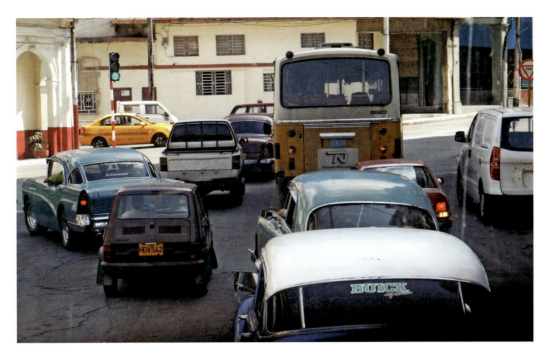

Traffic in downtown Havana.

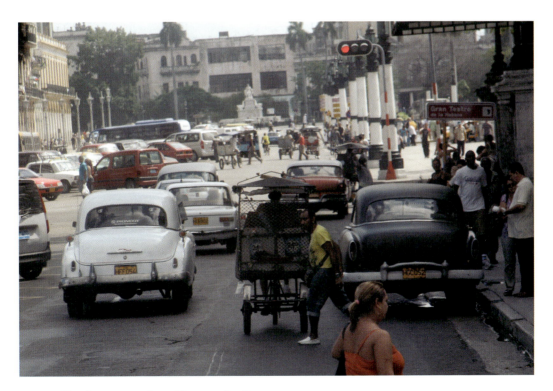

Classic cars on a busy Havana street.

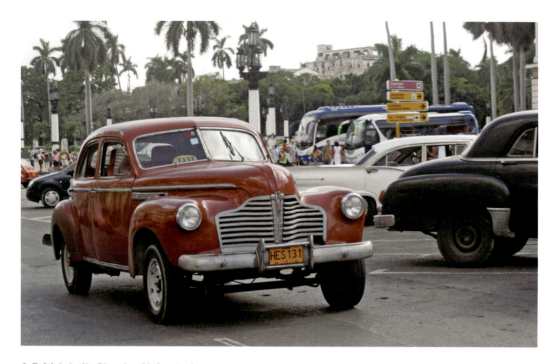

A British-built Chrysler Alpine taxi.

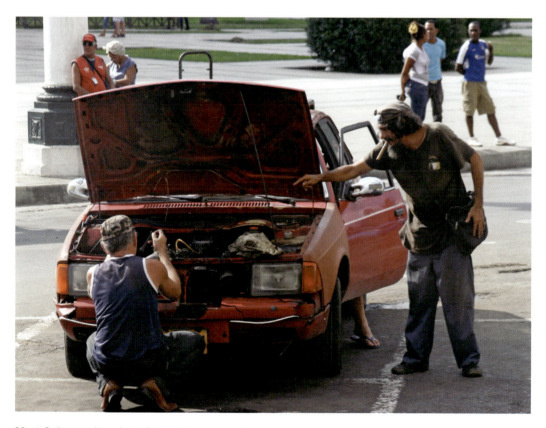

Most Cubans take a keen interest in cars and cigars.

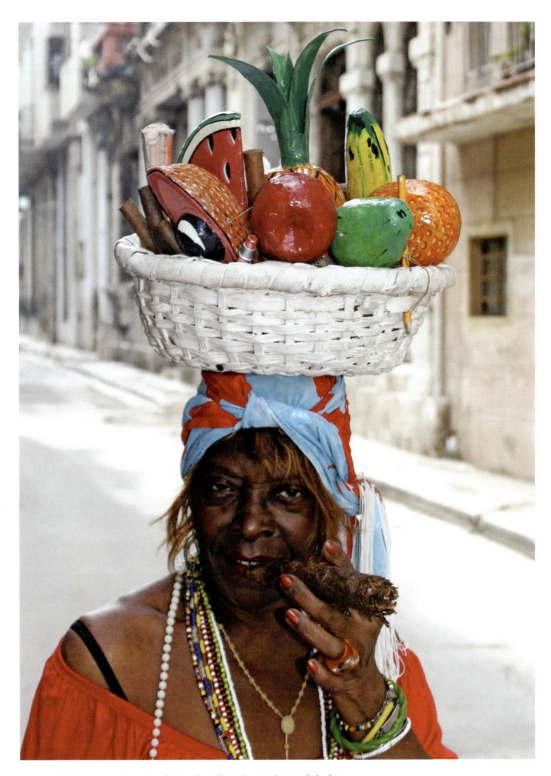
A Havanan in colourful garb enjoys her substantial cigar.

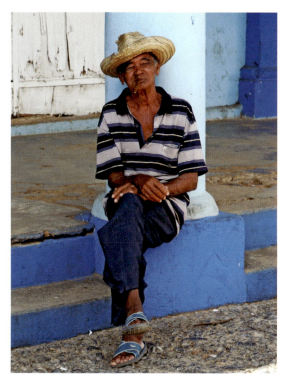

A relaxed Havana street-gazer.

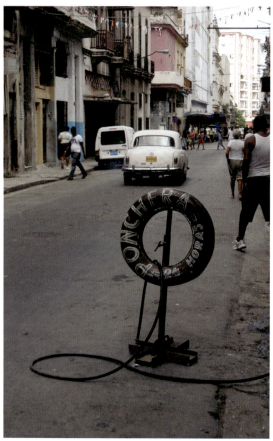

An alternative advertisement to a 'ponchera', possibly a garage or carwash.

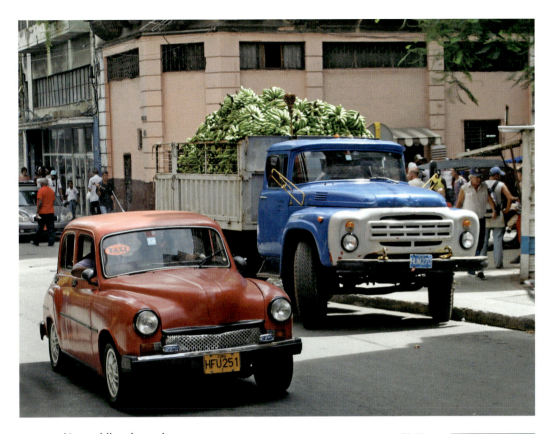

Above: Like cigars, bananas are an important export for Cuba, as well as being enjoyed at home. Cuban recipes include Cuban-fried banana, banana casserole and banana rum custard tart.

Right: A forlorn looking classic in a Havana backstreet.

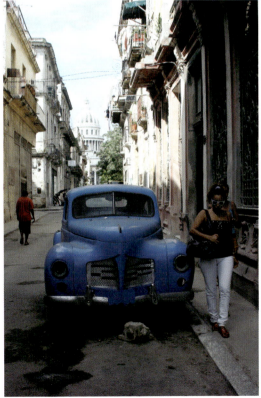

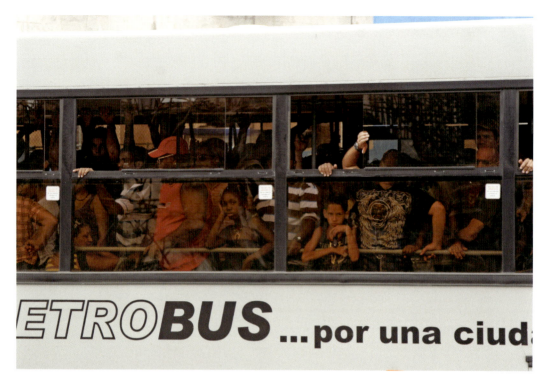
Most locals in Havana use the bus to get around.

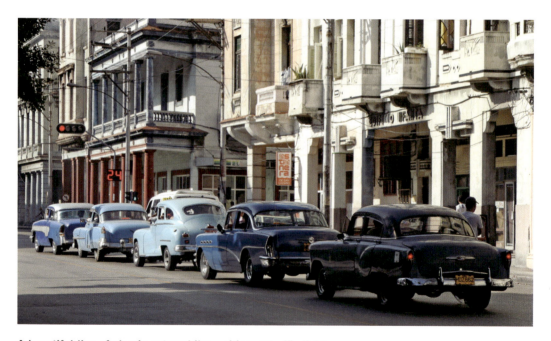
A beautiful line of classic automobiles waiting at traffic lights.

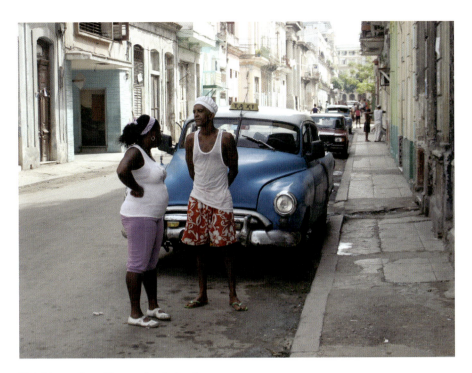
Neighbours in a Havana backstreet.

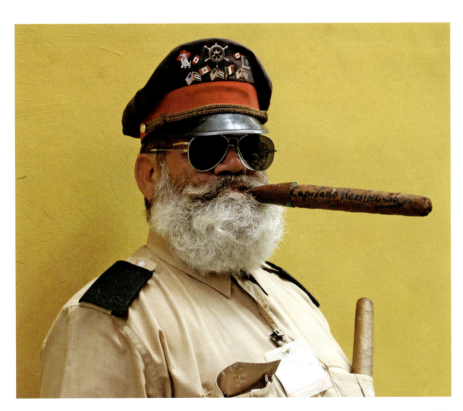
A colourful Cuban character enjoys his gargantuan cigar. Note the spare cigar in his shirt pocket.

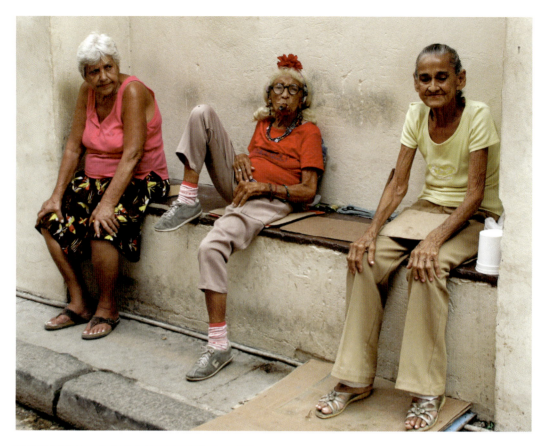

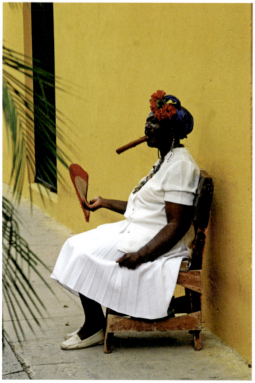

Above and left: **Elderly Cuban women enjoy their hand-rolled stogies. Only 5-10 per cent of cigar smokers are women, but Habanos specially created the Julieta, a smaller, milder version of the Romeo y Julieta cigar, aimed specifically at the fairer sex. It seems these women would rather have the real thing.**

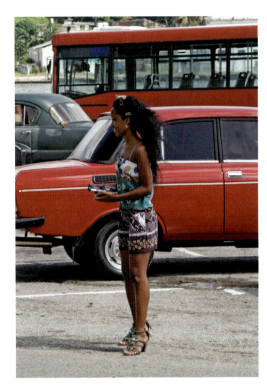

Right: **There are not only beautiful cars in Cuba.**

Below: **American automobiles are an icon of Communist Cuba.**

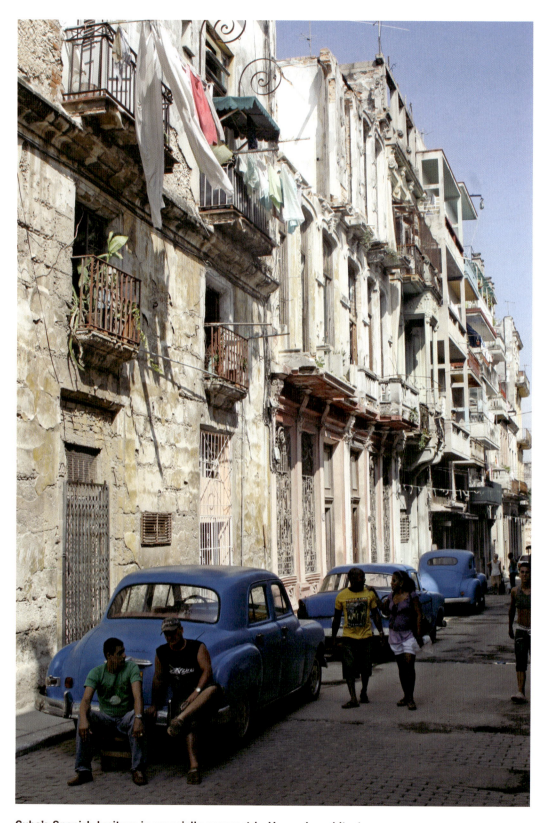
Cuba's Spanish heritage is especially apparant in Havana's architecture.

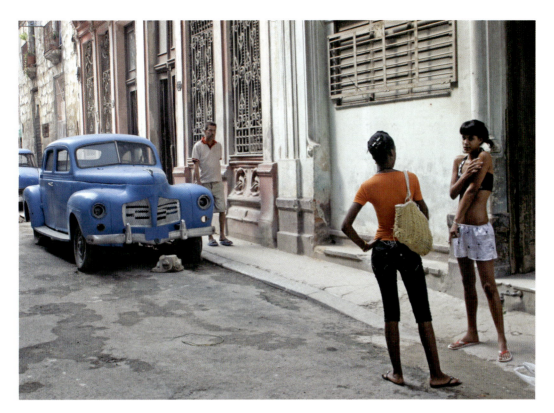

Above: **A tranquil backstreet in Havana.**

Right: **A long-legged Havanan beauty.**

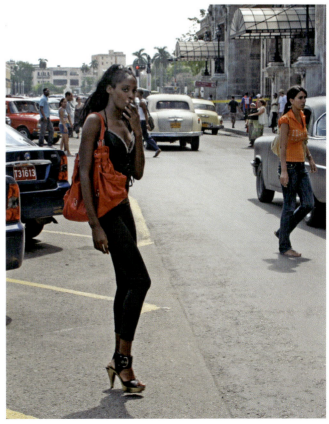

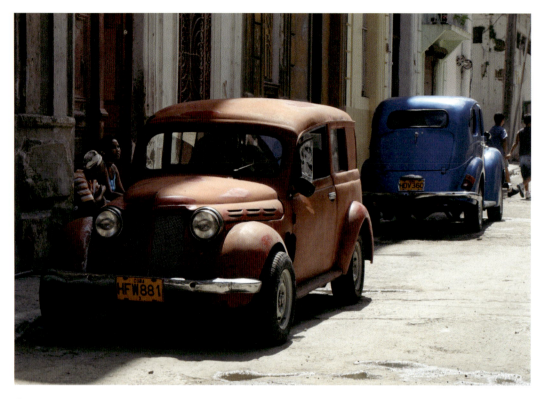
A scene redolent of the 1950s.

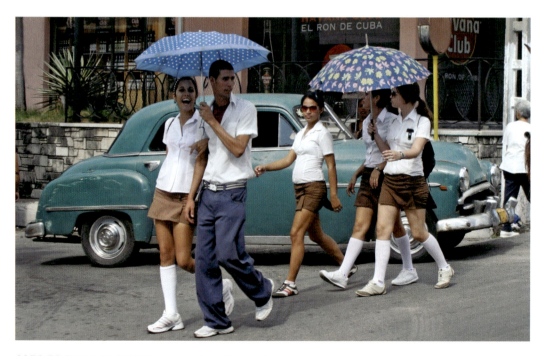
1951-52 Plymouth P-23 Cranbrook four-door sedan.

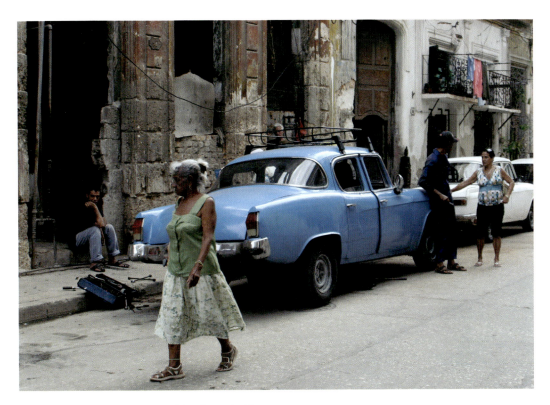

Car mechanics do good business in Havana.

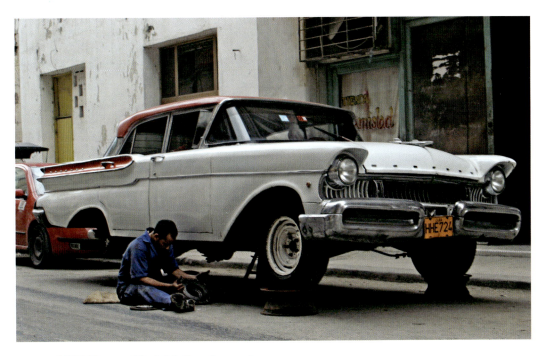

1957 Mercury Montclair four-door sedan.

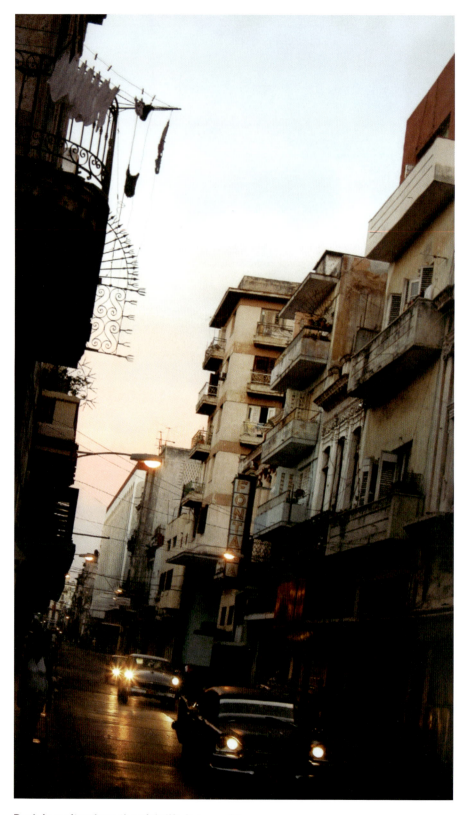

Dusk in a city where the nightlife is second to none.